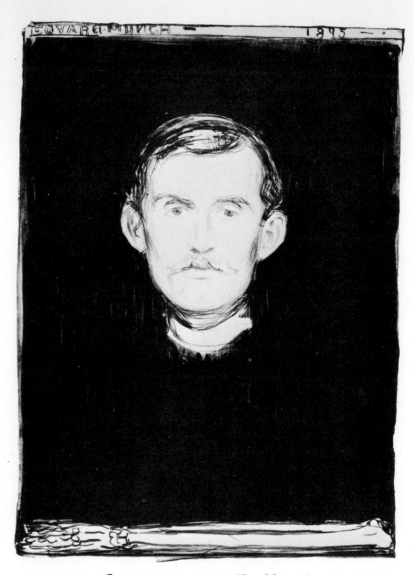

SELF-PORTRAIT. 1895. (See No. 18)

GRAPHIC WORKS OF
Edvard Munch

Selected and with an Introduction by
ALFRED WERNER

DOVER PUBLICATIONS, INC.
NEW YORK

TO MY WIFE LISA

Graphic Works of Edvard Munch is a new work, first pub-
lished by Dover Publications, Inc., in 1979.

International Standard Book Number: 0-486-23765-6
Library of Congress Catalog Card Number: 78-75256

Manufactured in the United States of America
Dover Publications, Inc.
180 Varick Street
New York, N.Y. 10014

INTRODUCTION

I

"In my art I have sought to get life and its meaning clarified for me. It has also been my intention to help others clarify life for themselves."—Munch at seventy.

It might be supposed that the Norwegian painter and printmaker Edvard Munch (1863-1944), like many other innovators in the field of the visual arts, was unknown in the United States prior to the mammoth Armory Show of 1913, where he was modestly represented by a few lithographs and woodcuts. Actually, as early as 1896, an American art critic resident in Norway reported to a New York art magazine that Munch had offended the moral feelings of his compatriots by exhibiting pictures unfit to be seen by young girls. The critic wisely added that it would be "a trifle absurd to confine art within the limits of a young person's imagination."

Paintings by Munch had crossed the ocean in 1890, but could probably only be seen by close friends of their new owner, the collector Richard A. McCurdy, president of the Mutual Life Insurance Company of New York. In December 1912, a few months before the opening of the Armory Show, Munch was represented in a New York group show, *Contemporary Scandinavian Art*, and his six pictures were duly noted by local critics. The writer for the New York *Sun* asserted that Munch had a concept of life and a world of motifs which had much in common with Strindberg's and Ibsen's. For the New York *Times* critic, Munch was "without question" the strongest painter in the show. This critic added: "He handles his brush with so profound an appreciation of its efficiency as a tool, he extracts from his pigment so full a measure of his manifold resources, that a fellow-painter looks at his work with the instant determination to pick up his own brush and try what can be done with it."

In 1915, J. Nielsen Laurvik, writing in the catalogue that accompanied the Scandinavian art show at the Panama-Pacific Exposition in San Francisco, praised the exhibitor Munch to the skies:

"His independence has given others courage to be themselves. As a revolutionary, original and disturbing force he occupies in Norwegian art a position akin to that occupied by Ibsen in Norwegian literature, and he has met with a somewhat similar reception in his own country. Accepted and acknowledged abroad as one of the greatest artists of modern times, he is rejected and despised at home by the majority of his own countrymen who can see nothing but madness and perversion in his masterly revelations of the psychic verities of the soul."

Altogether, fifty-six prints by Munch were shown, and he was awarded a gold medal. Four years later, fifty-seven of Munch's prints were exhibited on the East Coast, in New York's Bourgeois Galleries. By that time, sophisticated Americans were able to inform themselves about Munch through the pages devoted to him by a widely respected man of letters, the Philadelphian James Gibbons Huneker, who, in his book, *Ivory, Apes, and Peacocks*, a collection of his newspaper and magazine articles, had included a few unmistakably positive paragraphs written in 1901 within a review of the Munich Secession show. There "a room full of Munches" (*sic!*) caused the visitors to this "chamber of horrors" to indulge in "laughter and exclamations of disgust."

Huneker heartily disagreed with them, since he wrote: "His landscapes were those of a visionary in an Arcadia where the ugly is elevated to the tragic. Tragic, too, were his representations of his fellow-men. Such everyday incidents as a funeral became transfigured in the sardonic humor of this pessimist. . . . His death-room scenes are unapproachable in seizing the fleeting atmosphere of the last hour. . . . Psychologic, in the true sense of that much-abused word, are his portraits. . . . How finely he expresses envy, jealousy, hatred, covetousness, and the vampire that sometimes lurks in the soul of woman. He distorts, deforms, and with his strong, fluid line modulates his material as he wills, but he never propounds puzzles in form, as do the rest of the experimentalists. . . . He may suggest the erotic, but never

the lascivious. A thinker doubled by an artist, he is the one man north who recalls the harsh but pregnant truths of Henrik Ibsen."

Today museum-goers are able to identify with the Oslo master and to look at his paintings and prints as awe-inspiring and meaningful symbols of man's predicament. In this era of crisis, Munch's "art pour l'homme" seems to many of us more significant than the more detached, and perhaps less neurotic, work of such contemporaries of his as Matisse, Bonnard or Vuillard. All of these, to quote from Matisse's famous manifesto, dreamt of "an art of balance, of purity and serenity devoid of troubling or depressing subject matter." Munch, on the other hand, was not able, even if he had been willing, to produce a picture that might be likened to "a good armchair in which to rest from physical fatigue," as Matisse put it.

Though Munch spent as much time in France as he did in Germany, he was never as acceptable to Parisians as he was in the more progressive art circles of Berlin. As early as 1892 he caused a rift among German artists, angering the older, more conservative men with his extraordinary pictures and rallying around himself the young, restless, dissatisfied, bold avant-garde. He became one of the "fathers" of German and Austrian Expressionism, exerting an influence that was perhaps even stronger than that of Gauguin or Van Gogh, whose works had not yet penetrated Central Europe to any extent. It has been stated, "If you do not know Munch, you cannot understand Expressionism."

The Expressionists' art, like that of Munch, was one of spiritual pain. Their works were acts of self-liberation, outlets for souls and minds stirred by events and conditions that eventually led to the near-global conflagration known as World War I. But whereas the majority of the Expressionists were politically oriented, manifested anti-establishment attitudes, yearned for critical examination of all conventions and strove for an exposure of social evils, Munch was the great introvert who joined no group, had no preference for any party program, political or aesthetic. The Swiss psychiatrist Oskar Pfister could have had him in mind when, about 1922, he characterized the Expressionist as one who "creates out of the depth of things, because he knows himself to be in those depths."

Pfister went on: "To paint out of himself means to reproduce the intrinsic nature of things, the Absolute. The artist creates as God creates, out of his inner Self, and his own likeness . . . is always the self-representation of the artist's psychical state . . . all his pictures contain the fulfillment of secret desires, which are wholly hidden from him. . . . Whoever is conscious of a wave of emotion when looking at Expressionistic work proves thereby that he experiences the same distress."

Indeed, despite the vastness of the literature on Munch, the most succinct description of his work might well be chosen from Pfister's book *Expressionism in Art: Its Psychological and Biological Basis:* "a cry of distress, like a stream of lava propelled by the soul's misery, and a ravenous hunger for life." It is significant that one of Munch's most celebrated images, which he rendered in several media, bears the Norwegian title "Skrig," best rendered into English as "Scream" (". . . it is solely this translation which contains all the connotations of the prolonged, painful, harsh and loud human emotional vocal outburst Munch projected into the landscape of the Oslofjord," Reinhold Heller explained in 1973).

In a typical northern setting—extremely austere, like those of most of Munch's works—a young person of uncertain sex is seen standing on a bridge. The contracted oval of the mouth appears to be shaping a scream that reverberates over the bleak scenery, as if the individual were pursued by a demon. This picture is, undoubtedly, based on a personal experience of the artist. In a preliminary drawing, he portrayed himself leaning against the railing of the same bridge. "Trembling with fear," as he recalled, he saw the sky "like blood and flames" above the blue-black inlet of the sea, feeling "as if all nature were filled with one mighty unending scream." Even in the black-and-white lithograph version the "blood and flames" are evident. Expressionism may be said to have been born with "The Scream," perhaps the most striking portrayal of what Auden has called The Age of Anxiety.

It is seemingly part of the mission of art in modern society to make life more bearable for the creator and for others as well, to resolve pent-up emotions by bringing them to consciousness and permitting them expression. This potential is best described by Goethe in his drama *Torquato Tasso* when he has the tormented Italian Renaissance poet say triumphantly: "While other men are struck dumb by their pain, God empowered me to express my suffering." By the same token, Munch's "abnormality," his narcissism, his anxiety, found outlets in art more personal, unequivocal and haunting than any the world had seen before. Freud had already pointed to the power of art to mold fantasies "into new kinds of realities which are accepted by people as valuable likenesses of reality." Munch, who has even been dubbed by one critic as "the Sigmund Freud of painting," transmutes his inner world into shapes both frightening and redeeming.

II

"What does it all matter, as long as the wounds fit the arrows?"—Franz Kafka.

Munch might have developed quite differently as an artist had he not been the son of a fanatically religious physician and had he not rebelled by drifting into the bohemian milieu of Oslo. At the same time, his story is a negation of determinist philosophy insofar as he did not allow conditions and events to deflect him from the course he had chosen. Although he stood at the edge of a precipice, the winds of Fate were unable to blow him into the abyss; despite a pathological trend in his nature—manifested in alcoholism, misogyny, and behavior that was often asocial—as an artist he remained in tight control of his creative powers. He was wise enough to seek cure when it was desperately needed, and remained his own master until his death at eighty-one.

He was born on a farm in southern Norway, on December 12, 1863, but his family soon moved to the capital, then called Christiania (or Kristiania). Pain and suffering constantly haunted Munch. "The black angels of disease and insanity were on guard at my cradle," he was to write retrospectively. "I always felt that I was treated unjustly." He lost his mother when he was only five. Tuberculosis, which also affected Edvard, felled one of his sisters; another sister became mentally ill; his only brother died young. His father took Edvard along on his medical rounds in the slums of Christiania, for Dr. Munch believed that children must become aware at an early age of poverty, sickness and death. A stern disciplinarian, Dr. Munch carried his intense Lutheran convictions to extremes; as his son reported, he "could be almost insane in his violence" when punishing his offspring.

Edvard rebelled against this strict code in which pleasures were outlawed and the earthly pilgrimage was meant only as preparation for eternal existence in the hereafter. He briefly studied engineering. Then, to the utter dismay of his puritanical father, he not only turned to painting, but even joined the bohemians. In dimly lit cafés, positivism, anarchism and socialism were eagerly discussed. There was heavy drinking and even some use of drugs. Free love was preached and practiced. After the leader of the group, Hans Jäger, had published a novel that—by the standards of the time and place—dealt too frankly with sex, the authorities began to act. They suppressed the book and sent its author to jail. While there, Jäger wrote an enthusiastic article about Munch, then only twenty-two; it was to be one of the very few instances of encouragement the painter received in the early phase of his career.

Until his mid-forties, Munch's life was remarkably similar to that of his somewhat older contemporary Vincent van Gogh. There was the same restlessness, the constant moving from place to place. Both men sought love; but whereas Vincent desperately wanted to marry and raise a family, the suspicious Munch fled any liaison as soon as he felt threatened with bondage. One woman with whom he had broken because of her insistence upon marriage sent word that she was about to die and wished to talk to him for the last time. The artist arrived to find her wrapped in a shroud and lying on a bier flanked by two lighted candles. Suddenly she rose and said, triumphantly, "I knew that you would come." Seeing that her former lover, shocked by her deceit, was about to leave, she picked up a revolver and aimed it at her breast. Munch put his hand on the muzzle of the gun, which went off and injured his middle finger.

Munch himself might have conceived and painted this melodramatic scene. The charge of an almost hysterical self-pity can, indeed, be leveled against many of his works. But why should an artist camouflage his emotions? What had Munch to offer of greater value than his naked heart? In his pictures his explosive autobiography can be read, chapter by chapter.

There are nearly a hundred outspoken and revelatory self-portraits, through which Munch asked himself constantly: Who am I? What am I? Alienated from society, he had few friends and even they were not allowed any real measure of intimacy. A taciturn bachelor, pale and haggard like the figures who appear in his Oslo street scenes and Nordic landscapes, morbidly detached when in company, quiet when sober, he could be violent when intoxicated, and once accidentally killed a man in a brawl. A painted self-portrait of 1906 shows him as the melancholy introvert he was, sitting in an empty café with a bottle of wine before him. Two years later, at forty-five—an age by which most men, even artists, have managed to settle down—he was still a footloose vagabond of destructive and self-destructive bent. It was then in Copenhagen that, panic-stricken, on the verge of insanity, he had the wisdom to consult a psychiatrist who confined him to a clinic for several months.

Munch left the sanatorium an apparently "changed man." No more hard liquor, no more frenzied travel! He returned to his native land; after a few years he settled for good at Skøyen, near Oslo, where the forty-odd rooms of his spacious house Ekely ("Oak Grove") were quickly filled from floor to ceiling with canvases, drawings and prints. He gradually became

something of a national hero. The University of Oslo gave him commissions for enormous murals. Formerly scorned by Norwegian critics, he now received glowing tributes on several occasions. At the Paris World's Fair of 1937, his work dominated the Norwegian pavilion.

But either the doctor had succeeded too well in ridding him of the tensions that were a source of inspiration, or the flame had dwindled with advancing age. In any event, what the painter and printmaker produced from about 1909 until his death thirty-five years later generally lacks the vitality, the violent evocativeness, of the earlier work. The palette lightens, the forms open up, the sun enters, but the uninhibited emotionalism is gone. Gone is the "animal," the "magnificent thunderbird," as a German poet had described the younger Munch. Gone is the firebrand who had written, "Painting is for me like being ill or intoxicated—an illness of which I do not want to be cured, an intoxication which I cannot forego."

It is somehow impossible to imagine Van Gogh, Toulouse-Lautrec, Modigliani or Pascin as a comfortable elderly gentleman. Of course, Munch never deteriorated into the pathetic and almost ridiculous figure that James Ensor or Maurice Utrillo became in old age. Nevertheless, it is hard to understand how the restless maniac who was both admired and feared in the artistic circles of Paris and Berlin could be transformed into a tame, hypochondriacal hermit who took immense pains to insure that the room temperature at Ekely was kept constant and who went promptly to bed if told that he was not looking well. It is puzzling that this "encyclopedia of fin-de-siècle pessimism" later in life produced calm, brightly colored murals that extol the life-building forces of nature and hail man as a worker in a social collective.

The eight months Munch spent at Dr. Daniel Jacobsen's clinic can, therefore, be accepted as a watershed in his art. As he grew older, he had less and less to say, in every respect. Still, he never completely forgot the storms of the past. He was close to eighty when he painted a self-portrait that recapitulates the unrest of his youth (*Between Clock and Bed*, 1940–42, Munch-museet). A tall, gaunt man, still defiant and proud, he stands between a black grandfather clock and a bed onto which a black- and red-striped coverlet has been thrown. Above the bed hangs the picture of a female nude, as much a symbol of life as the clock is a symbol of death. Though this clock has no hands, we hear its inexorable, maddening tick. Was the change in Munch only outward? The same defiant, proud and rather paranoiac facial expression seen in this late canvas was already evident in a self-portrait of his student days. Perhaps much of the earlier Munch remained even when he was an elderly recluse. Whenever he dipped into the memory residue of his past and recreated old motifs, it was with at least some of the enthusiasm that had gone into his painting and especially his prints around 1900, though with greater detachment and less commitment, and certainly with less imagination.

At any rate, what he created between about 1884 and 1909 is sufficient to secure him a chapter in the history of modern art, as a major transitional figure from late nineteenth-century Naturalism and Impressionism to the core of twentieth-century Expressionism and Symbolism. He did not exaggerate when he claimed to have "blazed a new trail" with *The Sick Girl*, painted at the age of twenty-two. At twenty-six, a resident of Paris, he jotted in his journal, prophetically, "We should create living people who breathe and feel and suffer and love." He wanted to do pictures of the kind that would make the spectator "take his hat off just as he would in a church."

These convictions were certainly shared at the time by the ardent Van Gogh. Yet it was not long before another French artist, Maurice Denis, was to deliver his famous manifesto that a painting was "essentially a plane surface covered with colors assembled in a certain order." This pronouncement, essential to much of the work of the Post-Impressionists and the groups that followed, was to culminate in the antifigurative and antipersonal theories and practices of the mid-twentieth century.

Munch somehow combined these two approaches. Though this may not be evident at a quick glance, Munch's best work amalgamates the finest qualities of "abstract" art with the "realistic" message that makes a work of art spontaneously accessible to the beholder. He did not sacrifice form to idea, but condensed, synthesized and simplified shapes, and suppressed details of faces and landscapes. In his paintings he chose certain colors—such as bloody and violent reds, leprous greens, frightening blacks and mystical blues—mainly for their emotional, symbolic qualities; like many an artist of the 1950s, he also allowed paint to drip, to splash, unconcerned whether these accidental effects might mar the "beauty" of the surface in the traditional sense of the word.

When Munch was still at the start of his career, one of his teachers, the painter Christian Krohg, defended him against his numerous detractors by saying, "Perhaps this is music rather than painting." Krohg was right; his star pupil's works in all media are the free and spontaneous love and hate songs of a man who has been wounded deeply. Even the Expressionists of Central Europe, who hailed Munch

as their mentor, were often not as terribly concerned with rendering the tragic aspects of life as Munch, for whom even trees assumed an anthropomorphic form to reflect the melancholy state of his mind.

Love songs? One of the most obvious features of Munch's art is his antifeminism. Woman, for him, was a vampire who strangles man with her long hair, a destroyer rather than a giver of life. Even an historical theme like "The Death of Marat" is exploited to show woman as a triumphant murderess. Yet perhaps woman for him was actually a symbol, one of many symbols relating the physical with the moral world and dramatizing the inner conflicts of an ultra-sensitive man trying to free himself of an overpowering dread of life, to cope with his anxiety and the desires he had renounced.

His misogyny may also have been an antidote to the sensualistic worship of women prevalent in the Belle Epoque, a period filled with noisy merrymaking that drowned out the distant thunder of war and revolution. Munch recognized the falseness of the current feeling of security, as did Van Gogh, who wrote to a friend, "We are living in the last quarter of a century which will end again in an enormous revolution. My God, those anxieties. Who can live in the modern world without catching his share of them?"

Munch caught his share, both as a man and, toward the end of his life, as an independent artist and freedom-loving Norwegian. He must have been told that German Reichsminister Göring, on a visit to the Kronprinzen-Palast, Berlin's pre-World War II equivalent of New York's Museum of Modern Art, had taken offense at his paintings, and could not be persuaded that they were characteristically Nordic. In 1937, labeled "degenerate," all of Munch's works that had been acquired by German museums—eighty pieces in all, in different media—were confiscated. When the Norwegian Fascist leader Vidkun Quisling nevertheless felt compelled to invite the famous septuagenarian artist to join a pro-Nazi honorary council of art, Munch naturally refused. One day two German officers called on him at Ekely. Whether the visit had any sinister implications, or was prompted by mere curiosity, the artist, who had been living in jealously guarded solitude for many years, received them with great anxiety, expecting that the two would return with trucks to cart off his hoard and put it to the torch. Apparently the two emissaries were frightened by the incredible clutter they saw; they left, never to come back.

Munch did not live to see his country's liberation from the Nazi yoke in 1945, as he died of a heart attack on January 23, 1944. But he must have antici-pated a new era, since he left to the city of Oslo, unconditionally, all the works—his "children," he liked to call them—in his possession: more than one thousand oils, more than four thousand watercolors and drawings and more than fifteen thousand impressions of his graphics in different states. Oslo also inherited the Munchs owned by the artist's sister. These treasures, augmented by gifts from private collectors, eventually were installed in a large, modern gallery, the Munch-museet of Oslo, opened in 1963, where the holdings are shown in rotation.

III

"In Munch we recognize one of the greatest graphic artists of his time, comparable to a Dürer, a Rembrandt, a Goya, a Hokusai, continually seeking new means of expression"— J. P. Hodin, in "Edvard Munch" (1972).

If one accepts Munch's claim that he had always walked along the edge of an abyss, one may also believe his boast that he was able to see the man behind the mask. A dangerous manner of living is more likely than a tranquil one to turn a person into a clairvoyant. It is significant that, by and large, the Impressionists, who were more interested in quiet landscapes than in the troubled inner side of man, contributed little that was new to the art of printmaking (their leader, Claude Monet, never concerned himself with the creation of prints). By the same token, it is not astonishing that the restless Post-Impressionists included one of the most prolific printmakers of all times, Henri Toulouse-Lautrec, who, in his very short but extremely hectic career, produced hundreds of etchings and lithographs, many of them as disturbing as those of his Norwegian contemporary. The woodcuts of Gauguin, another major Post-Impressionist, were not numerous, but in their roughness and ferociousness they anticipated those of the much younger Munch; the Norwegian may have been persuaded by the example of this French experimenter that the designing, cutting and printing of woodcuts had to be done by one and the same hand, and that an unpolished surface was desirable because of the challenging resistance it offered to the artist's knife.

Thus, for Munch, whose work constitutes the transition from Post-Impressionism to Expressionism, printmaking was something that came naturally, even though he was entirely self-taught in this area and approached it only after having devoted a full decade exclusively to oil painting. For the German Expressionist printmakers, most of them much

younger than he, Munch was a sort of "father." He has left us, according to one count, no fewer than 714 different prints: 378 lithographs, 188 etchings and engravings, and 148 woodcuts.

Indeed, it would have been surprising if a man as versatile as Munch—who even tried his hand at sculpture, and who revealed a considerable literary talent —had failed to explore the possibilities afforded by printmaking. But this was more than a sideline for Munch, whose prints were never overshadowed by his paintings. Many will agree with his recent biographer Thomas M. Messer, who asserts that when Munch made prints on the same subjects as his oils, the prints were improvements: "Munch's ultimate fame may rest securely upon his many well-preserved masterpieces in the graphic media" (*Munch*, 1973). Earlier, Otto Benesch had claimed that Munch's woodcuts had "an original power and primitive grandeur far surpassing the spiritual intensity of the paintings" (*Edvard Munch*, 1960).

It is true that Munch was over thirty, and had painted seriously and professionally for more than a decade, before he began printmaking. Still, for him a print meant more than a substitute for a drawing as a preliminary study for a painting, more than a mere reproduction of a drawing or an oil. For Munch, a print was as final, as perfect, as independent a statement of artistic aims and expression of thought, as any canvas. In fact, since he could not easily part with an image once he had created it, and it would often obsess him over many years, the print enabled him to occupy himself with a pictorial idea again and again, refining his conception to the ultimate formal simplicity and significance. Last but not least, his prints enabled him to reach a very large audience.

At the same time, some print media permitted him to achieve a spontaneity within a physically small area that was denied him in the making of his oils, many of which were large (for instance, the eleven monumental canvases that were to cover the walls of the assembly hall in the University of Oslo). In view of this desire for freedom, it is not surprising that more than half of his prints are lithographs. On the smooth, yielding surface of a limestone block, zinc plate or transfer paper, he could use a greasy crayon, pen or brush with the speed at which an articulate man can utter words. These tools offered him a psychic catharsis, helping him to reveal his strongest feelings, his deepest thoughts. The lithographs often seem to be those of a daydreamer whose hand has raced over the surface in front of him, releasing inner images, freeing the subconscious mind from havoc-wreaking monsters. Such demons may oppress an artist—as they did Munch—but, being an artist, he does not surrender. Instead, he may be able to

vanquish them by his craft, just as the prehistoric hunter subdued his fear of powerful animals by drawing their likenesses on cave walls. And if an artist cannot strike down his demon, he may at least disarm him by looking straight into his terrifying face.

Munch appears to have taken special delight in another graphic technique, drypoint. Unlike etching, a "wet" method which uses acid to bite the required lines into the metal, a drypoint engraving is scratched directly onto a zinc or copper plate with a sharp steel point (graver). Indeed, Munch's very first ventures into printmaking were two tiny drypoints he did in Berlin in 1894. For a while he always carried a small metal plate in his pocket; seated in a café, he might take it out and compose an image on it with unfailing sureness, as naturally as if he were working with a pencil or pen. Munch often combined drypoint with another technique, such as etching or aquatint, or he would mix etching and aquatint. By the same token, he might work on a finished print with a colored crayon or with a brush dipped in watercolors or oils.

Munch also expanded the possibilities of the woodcut, although the honor of reviving that medium, long held in low esteem, indubitably goes to Gauguin. It was he, fifteen years older than Munch, who, mostly during his final sojourn in Oceania (1895–1903), produced some extraordinary woodcuts by working the block with an ordinary gouge (the only tool available to him) and inking the block unevenly in an effort to make the resulting print as barbaric, strong and natural as possible.

No more than about a dozen of Gauguin's woodcuts, as "primitive" and crude as they are poetic, have come down to us. By contrast, Munch's output in this category of printmaking was quite large. While he could have obtained smoothly polished blocks of high-quality wood, like Gauguin he preferred to exploit the special rough structure of the raw, hard-pine slats from packing cases. He chose long-cut rather than cross-cut timber. He also utilized grain and saw marks as welcome background textures. Though sophisticated tools were accessible, he dug into the tough wood with a coarse knife, disliking the mechanical virtuosity that prevailed in the nearly "perfect" conventional wood engravings of the late nineteenth century, which lacked vigor, force and, above all, that dose of "ugliness" without which a work of art is almost worthless, aesthetically speaking. Occasionally he would also apply color. There exist in some cases ten or more impressions of the same woodcut, each in a different color. To produce a print in several colors, Munch divided the block into pieces, which he inked separately in dif-

ferent hues. He then reconstructed the rectangle like a jigsaw puzzle, and put it through the press.

Thus, woodcuts for Munch meant something quite different from the quick release of nervous energy made possible by drypoint or lithography. Here, he wrestled patiently with the refractory material, a task that required strict discipline. While imposing limitations upon the artist, the woodcut medium permits the heightening of emotional tensions through the creative dialogue between heavy blacks and stark whites. Few artists make us realize as fully as Munch that white can be a stark, cruel color or a tender and lyrical one, and that black can be soft or dramatic, deep or brittle. The woodcut, it seems, was the most appropriate medium for an introspective man like Munch who constantly asked questions concerning life and death, and who saw the world in opposites, conflicts and conflagrations. Whereas his interest in the technique of engraving had waned by 1915 or 1916, his fascination with woodcut lasted almost to the end of his life.

Frequently, an artist tries out an image in drawings or prints before engaging in the more demanding and time-consuming task of painting a large oil. In the case of Munch, the procedure was often reversed: an oil done years before might give birth to a print in which the theme and the composition were borrowed quite frankly and unashamedly from the earlier work. On the other hand, these images are never identical, and the later picture is likely to indicate, often in a subtle way, Munch's more recent experiences, psychological or aesthetic. Many of Munch's favorite motifs were tackled in several media. His most popular image, "The Scream," was first set down about 1893 as a pastel on a piece of cardboard. In the same year, the first oil (now in Oslo's National Gallery) was created. Two years later, Munch made the lithograph reproduced in the present volume, which is the most powerful summarization of the intense feeling he wished to convey. Invariably, Munch's prints after oils, far from being "minor" or "secondary" works, tend to deepen the meaning of the painted original.

The prints also indicate the path of Munch's aesthetic development, although the earliest phases—the near-academic work of the young student and the subsequent blending of Naturalism and Impressionism—are missing, since Munch had thrown these influences overboard by the time he took his first steps as a printmaker. But what a historian has called the "long, sensitive, sinuous line that reminds us of seaweed or creeping plants" can be found in some of his early prints, linking Munch to the Art Nouveau movement that flourished around 1900 (though his works are more evocative than decorative). His prints are also contributions to the Symbolist International, just as concerned with philosophical attitudes—the emphasis being placed on dream, withdrawal, rejection of reality—as with new techniques or artistic solutions. They finally lead to nascent Expressionism, anticipating the raw emotionalism of Kirchner, Kokoschka and Schiele.

Although complete knowledge of Munch as an artist demands familiarity with his paintings, his prints give an accurate idea of what he stood for. It is safe to say that, had Munch never dipped a brush into pigment, he would have gained immortality on the strength of his works on paper alone. Nearly all the themes revolving around Eros and Death turn up in this graphic work, which also includes many self-portraits—from the lithograph that shows the earnest, thoughtful man of thirty-two (the base is framed by an ominous skeleton-like forearm) to the hectograph in which the artist, aged seventy-two, is obviously taking leave of the world.

His prints, then, are sufficient to show us what Edvard Munch was like: a man brave enough to raise important questions, though he knew perfectly well that the answers would not be given to him, that they were behind the last door, locked forever to him as to all his fellow mortals.*

*An excellent brief discussion of the Norwegian artist as a printmaker is included in the article "Edvard Munch as a Graphic Artist" in the catalogue of the 1975 Munch exhibition at the Konsthall (Arts Center) at Malmö, Sweden. The author of this essay, Pål Hougen, who is the director of the Munch-museet in Oslo, writes about the artist's experimentations and innovations: "His etchings, lithographs and woodcuts are the result of his struggle with a material: the drypoint technique forced upon him a delicacy of drawing that his unique works in pencil, ink and crayon seldom attain. The gouge compelled him to simplify, which makes his woodcuts more convincing summaries of his most important motifs than the paintings from which they were derived. . . . In Clot's workshop [a famous Parisian firm of lithographers] he attacked the stones with a spatula. . . . He was familiar with the fretsaw . . . he divided the [woodcut] blocks into many pieces which he colored individually. He fastened them to a sheet of cardboard with drawing pins so as to keep them in place when the roller pressed the paper against them. He soon learned to treat the white outline around each piece as a refinement. If necessary he used an extra tint plate; but after a few years he discovered that a single, undivided block could be used for several colors without the need for a fretsaw or for extra blocks."

LIST OF PLATES

With the exception of No. 71, the dimensions given are those of the image area rather than the plate area. They are expressed in millimeters (roughly 25 mm = 1 inch), height before width. The S-numbers are those of Gustav Schiefler's standard catalogue of Munch's prints, published in two volumes as follows: *Verzeichnis des graphischen Werkes Edvard Munchs bis 1906*, Bruno Cassirer, Berlin, 1907 (containing items S.1 through S.247); and *Edvard Munch: das graphische Werk*, Euphorion Verlag, Berlin, 1928 (containing items S.248 through S.513 plus the supplement). The MS-numbers used for the three items produced later than the Schiefler catalogue are those of the unpublished listing of the works the artist left to the city of Oslo.

and even "Back Street," the latter, at least, being an indefensible translation.

24 THE CABARET. 1895. Lithograph. 410 x 628. S.37. This is usually called "The Music Hall," but that is an inexact name for this type of establishment. The specific place depicted by Munch was the "Academy of Music" on the Friedrichstrasse in Berlin.

25 AT THE CLINIC. 1896. Lithograph. 330 x 540. S.55.

26 GIRL WITH HEART (OR, THE MAIDEN AND THE HEART). 1896. Etching. 238 x 337. S.48.

27 UNDER THE YOKE. 1896. Etching and drypoint. 236 x 330. S.49.

28 KNUT HAMSUN. 1896. Drypoint. 279 x 183. S.52. This portrait of the eminent Norwegian author was published in the German magazine *Pan* (Vol. II, No. 2).

29 YOUNG GIRL AT THE SHORE (OR, THE LONELY ONE). 1896. Color mezzotint. 287 x 217. S.42.

30 ANXIETY. 1896. Color lithograph. 420 x 385. S.61.

31 ANXIETY. 1896. Woodcut. 460 x 377. S.62.

32 THE URN. 1896. Lithograph. 460 x 265. S.63. In the first state of this print, a grinning face appears on the urn.

33 ATTRACTION (OR, LOVERS ON THE SHORE). 1896. Lithograph. 472 x 355. S.65.

34 JEALOUSY. 1896. Lithograph. 465 x 565. S.58. This is the larger of the two similar Munch prints with this title and theme.

35 LOVERS (OR, LOVERS IN THE WAVES). 1896. Lithograph. 310 x 419. S.71.

36 DEATH CHAMBER. 1896. Lithograph. 400 x 540. S.73.

37 SEPARATION (OR, RELEASE). 1896. Lithograph. 488 x 585. S.67.

38 AUGUST STRINDBERG. 1896. Lithograph. 446 x 315. S.77. In a later state of this print, the misspelling "Stindberg" of the Swedish dramatist's name is corrected.

39 STÉPHANE MALLARMÉ (FRENCH POET). 1896. Lithograph. 401 x 289. S.79.

40 MOONLIGHT. 1896. Color woodcut. 412 x 467. S.81.

41 EVENING (OR, MELANCHOLY; OR, ON THE BEACH). 1896. Color woodcut. 376 x 455. S.82.

42 MAN'S HEAD IN A WOMAN'S HAIR. 1896. Color woodcut. 546 x 381. S.80. In this design for a book jacket, the man's head resembles Munch's depictions of the Polish writer Stanislaw Przybyszewski.

43 MODEL WITH HOOD AND COLLAR. 1897. Mezzotint. 398 x 295. S.86. This is usually called "Model with Cape and Collar," but the word *Kapuze* in Schiefler's catalogue surely refers to the headgear.

44 FUNERAL MARCH. 1897. Lithograph. 555 x 370. S.94.

45 SALOME PARAPHRASE. 1898. Woodcut. 400 x 250. S.109.

46 THE KISS. Fourth version, 1902, of a print dating to 1897/8. Woodcut. 447 x 447. S.102.

47 OLD SEAMAN (OR, OLD FISHERMAN). 1899. Woodcut. 435 x 355. S.124.

48 ASHES, II (OR, AFTER THE FALL). 1899. Lithograph, hand-colored. 353 x 454. S.120.

49 WOMAN (OR, SPHINX). 1899. Lithograph. 462 x 592. S.122.

50 HEAD OF A YOUNG WOMAN SILHOUETTED AGAINST THE SHORE. 1899. Color woodcut. 465 x 413. S.129.

51 THE FAT HARLOT. 1899. Woodcut. 250 x 199. S.131.

52 "WE ENJOYED YOUR COMPANY." 1899. Lithograph. 400 x 525. S.121. Schiefler's German title, "Der Dank an die Gesellschaft," has been translated in various ways; the most common version, "Thanks for the Party," would make more sense if the leavetaking occurred indoors; the version "Homage to Society" is decidedly inferior.

53 SEASCAPE (OR, STUMP, MOONLIGHT; OR, STUMP, MYSTIC SHORE). 1899. Woodcut. 372 x 572. S.125.

54 TWO PEOPLE (OR, TWO BEINGS; OR, THE LONELY ONES). 1899. Color woodcut. 395 x 530. S.133.

55 ENCOUNTER IN SPACE. 1899. Color woodcut. 181 x 251. S.135.

56 DEAD LOVERS. 1901. Etching and aquatint. 320 x 492. S.139.

57 DEAD MOTHER. 1901. Etching and aquatint. 311 x 481. S.140.

58 NUDE (OR, SIN). 1901. Color lithograph. 495 x 396. S.142.

59 AT NIGHT (OR, PUBERTY). 1902. Etching. 186 x 149. S.164.

60 IBSEN IN THE CAFÉ OF THE GRAND HOTEL, CHRISTIANIA. 1902. Lithograph. 420 x 590. S.171.

61 MR. AND MRS. WALTER LEISTIKOW. 1902. Lithograph. 522 x 868. S.170.

62 DR. MAX LINDE. 1902. Drypoint. 320 x 222. S.178. This print and No. 64 are from Munch's portfolio *Aus dem Hause Max Linde* (From Max Linde's House [in Lübeck]).

63 VIOLIN RECITAL. 1903. Lithograph. 480 x 560. S.211. The violinist is Eva Mudocci (see also

No. 66), the pianist Bella Edwards. The title "Violin Concert" is merely bad English for Schiefler's *Violinkonzert*.

64 GARDEN FRONT OF DR. LINDE'S HOUSE. 1902. Lithograph. 165 x 385. S.176. This was the title-page illustration for the portfolio *From Max Linde's House*.

65 LÜBECK. 1903. Etching. 470 x 615. S.195. At the right is the Holstentor, one of the city's medieval gates; at the left, old warehouses.

66 MADONNA (OR, THE BROOCH; OR, EVA MUDOCCI). 1903. Lithograph. 600 x 460. S.212.

67 SALOME. 1903. Lithograph. 405 x 305. S.213.

68 VISIT OF CONDOLENCE. 1904. Woodcut. 495 x 600. S.218a (from Schiefler's supplement). Cut in 1904, this block was not printed until many years later. The title "Funeral Visit" is a poor translation of the German title.

69 MAN AND WOMAN KISSING. 1905. Color woodcut. 400 x 540. S.230.

70 HEAD OF A CHILD. 1905. Drypoint. 164 x 118. S.220.

71 ANDREAS SCHWARZ. 1906. Drypoint. Plate dimensions 275 x 207. S.250.

72 LITTLE NORWEGIAN LANDSCAPE. 1907. Drypoint. 90 x 130. S.260. This print was specially created for the deluxe edition of the first part of Schiefler's catalogue.

73 THE DEATH OF MARAT. 1906/7. Color lithograph. 440 x 345. S.258.

74 TIGER'S HEAD. 1908/9. Lithograph. 185 x 210. S.288.
 MANDRILL. 1908/9. Lithograph. 260 x 147. S.291. Often incorrectly called "Gorilla."
 In the impression owned by The Museum of Modern Art, these two appear on one large sheet along with two other Munch lithographs (S.276 and S.292).

75 THE FOREST. 1908/9. Lithograph. 335 x 420. S.312. This print and the one following are from Munch's series *Alfa og Omega* (Alpha and Omega), published by the artist in Copenhagen in 1909. This pictorial satire on woman's infidelity deals with the first human couple in paradise.

76 OMEGA'S EYES. 1908/9. Lithograph. 230 x 180. S.319.

77 PROFESSOR DANIEL JACOBSEN. 1908/9. Lithograph.
515 x 295. S.273. Jacobsen was the psychiatrist who treated Munch in Copenhagen.

78 SELF-PORTRAIT. 1912. Lithograph. 310 x 275. S.358.

79 HEAD OF A MAN BELOW A WOMAN'S BREAST. Printed 1908/9, but cut earlier (ca. 1898). Woodcut. 445 x 190. S.338.

80 ON THE JETTY. 1912. Lithograph. 385 x 520. S.380. This print is usually called "On the Bridge," a simple translation of Schiefler's title, "Auf der Brücke"; but Schiefler's commentary makes it clear (as does the picture) that this is a *Landungsbrücke*—a jetty, pier or wharf.

81 YOUNG MAN AND WOMAN IN A FIR FOREST (OR, LOVERS IN A PINE WOOD). 1915. Color woodcut. 320 x 600. S.442.

82 THE KISS ON THE HAIR. 1915. Woodcut. 155 x 168. S.443.

83 PICKING APPLES (OR, NEUTRALS). 1916. Color lithograph. 543 x 490. S.459. This print represents the gains made by neutral countries during the "storms" of the First World War.

84 THE PUMPROOM AT THE WIESBADEN SPA. 1920. Lithograph. 260 x 380. S.497. The translation "Health Resort, Wiesbaden" is too vague.

85 CROWDS IN THE BAHNHOFPLATZ, FRANKFURT. 1920. Lithograph. 305 x 415. S.510. The large square in front of the main railroad station of Frankfurt am Main is filled with people. If the occasion was a memorial service for the murdered foreign minister Walther Rathenau, as has been stated, the print could not be earlier than 1922.

86 THE LAST HOUR (OR, COURTYARD IN ELGESAETER CONVENT). 1920. Woodcut. 432 x 580. S.491. This represents the final scene in Ibsen's historical play *The Pretenders* (that is, claimants to the throne).

87 SELF-PORTRAIT WITH WINE BOTTLE. 1925/6. Lithograph. 420 x 505. MS.492.

88 GIRLS ON A JETTY. 1920. Woodcut and color lithograph. 496 x 429. S.488. For "jetty" versus "bridge," see the remarks on No. 80 above.

89 BIRGITTE, III (OR, THE GOTHIC GIRL). 1931. Color woodcut. 515 x 325. MS.703. The spelling "Brigitte" sometimes encountered is wrong.

90 SELF-PORTRAIT WITH HAT. 1927. Color lithograph. 203 x 188. MS.456.

PICTURE SOURCES

Editor and publisher are grateful to the following individuals and institutions for supplying photographs of Munch works and permission to reproduce them in the present volume.

Art Institute of Chicago: 3, 4, 7, 8, 10, 20, 22, 24, 29, 31, 33, 34, 36, 39, 46, 49, 50, 51, 57, 59, 60, 63, 66, 68, 70, 76, 83, 88.
Joseph H. Wrenn Fund: 21.

Collection, The Museum of Modern Art, New York: 17, 78.
Abby Aldrich Rockefeller Fund: 14, 30, 41, 55.
Acquired through the Lillie P. Bliss Bequest: 11.
Gift of Abby Aldrich Rockefeller: 52.
Gift of Bertha M. Slattery: 71.
Gift of James Thrall Soby: 58.
Gift of J. B. Neumann: 62.
Gift of Samuel A. Berger: 74, 87.
Given anonymously: 1, 15.
Mathew T. Mellon: 19.
Phyllis B. Lambert Fund: 54.
Purchase: 12, 28, 32, 43, 61, 84, 85, 89, 90.
The William B. Jaffe and Evelyn A. J. Hall Collection: 5, 16, 40, 42, 48, 73.
Transferred from the Museum Library: 72.

Fogg Art Museum, Harvard University, Cambridge, Mass.: 35, 53.

Francis Calley Gray, George R. Nutter and Jacob Rosenberg Funds: 9.
Gift of Joseph Pulitzer, Jr. in memory of Frederick B. Deknatel: 69.

Mr. and Mrs. Lionel C. Epstein Collection, Washington D.C. (photographs by Zeki Findikoğlu): 45, 64, 65, 75, 80, 81, 82, 86.

Museum of Fine Arts, Boston
Harriet Otis Cruft Fund: 47.
William Francis Warden Fund: 27, 37, 44, 56.

National Gallery of Art, Washington, D. C.
Rosenwald Collection: 26, 77.

Oslo Kommunes Kunstsamlinger, Munch-museet: 2, 6, 18, 23, 25, 79.

Prints Division, The New York Public Library, Astor, Lenox and Tilden Foundations: 67.

GRAPHIC WORKS OF

Edvard Munch

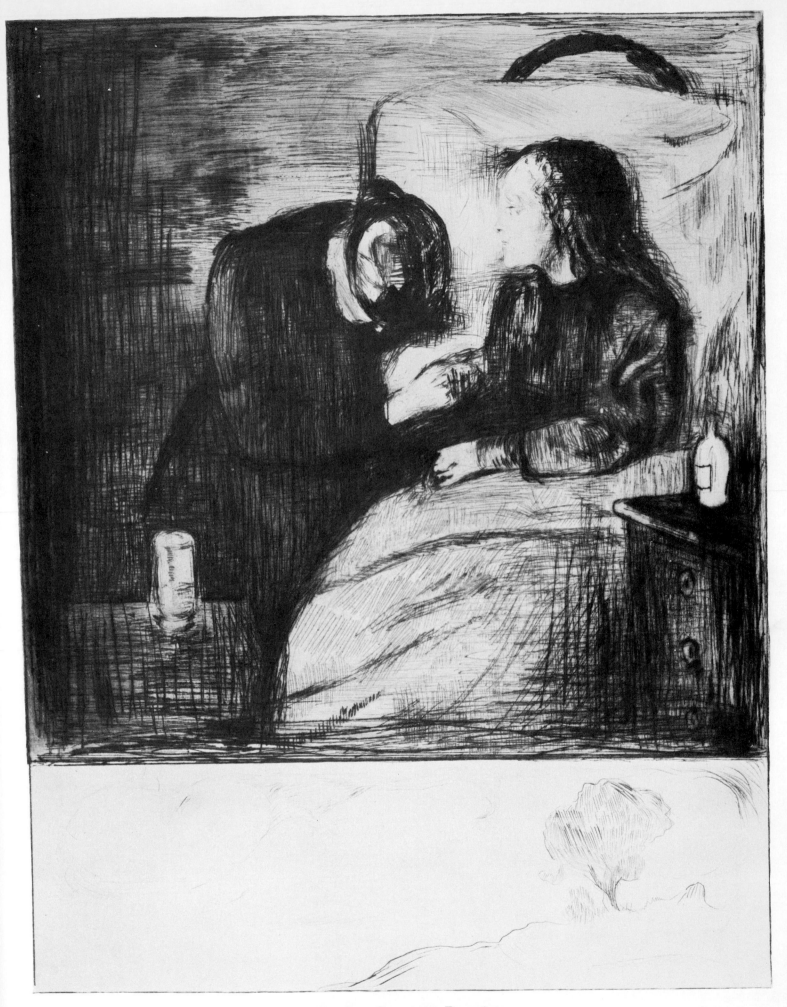

1 THE SICK GIRL. 1894. Drypoint.

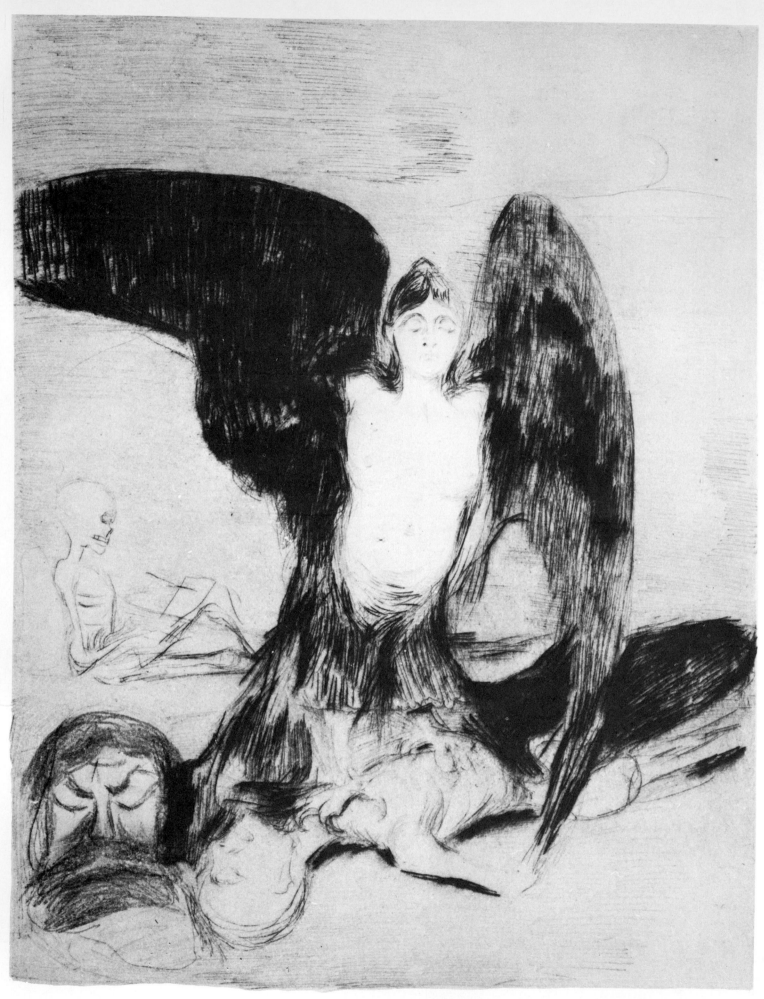

2 THE VAMPIRE. 1894. Drypoint.

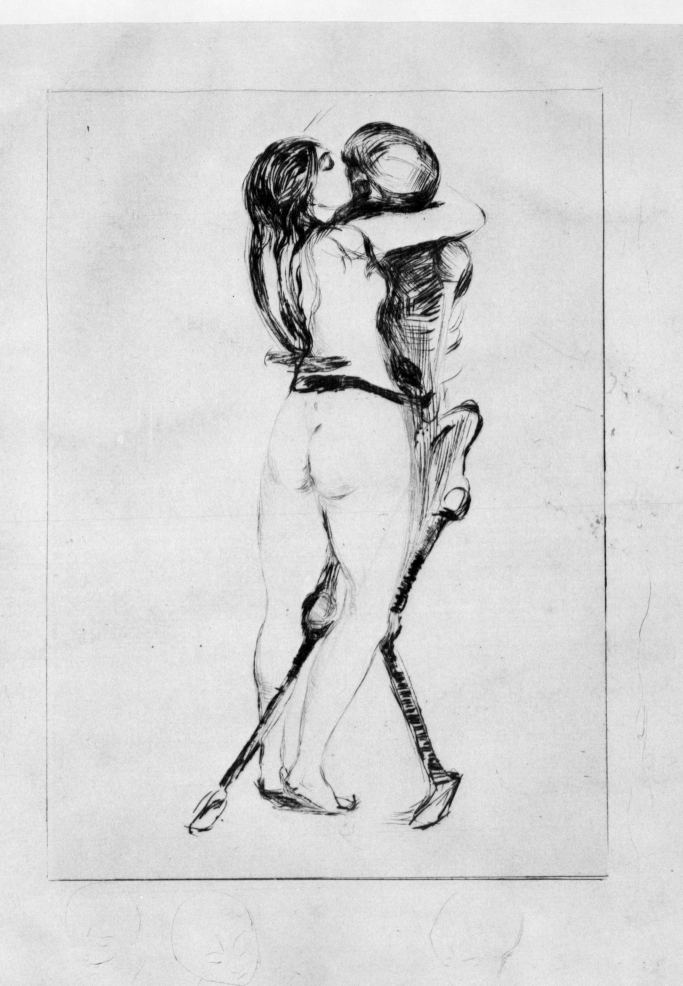

3　Death and the Maiden. 1894. Drypoint.

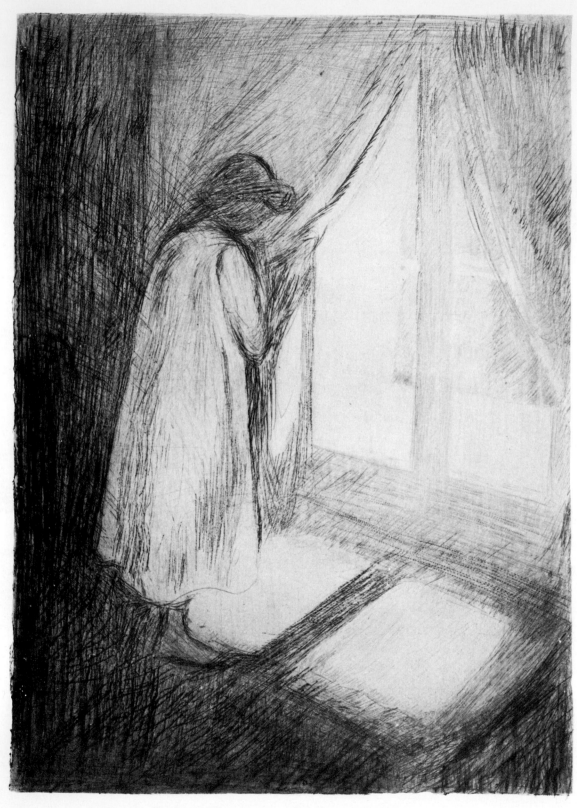

4 GIRL IN A CHEMISE AT A WINDOW. 1894. Drypoint.

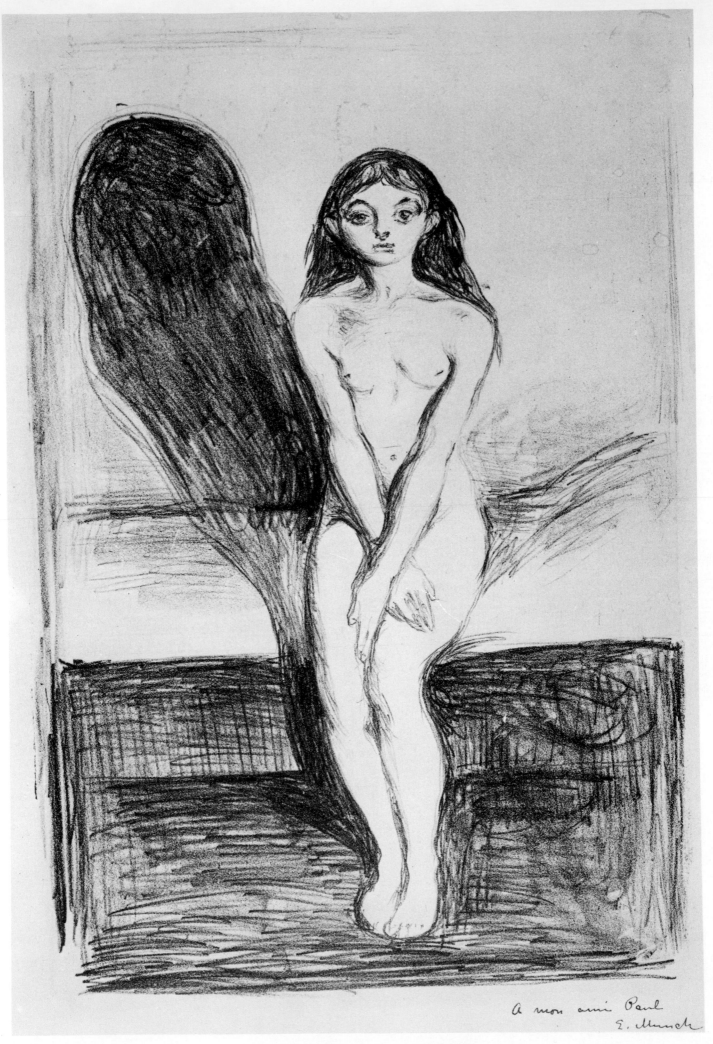

5 THE YOUNG MODEL. 1894. Lithograph.

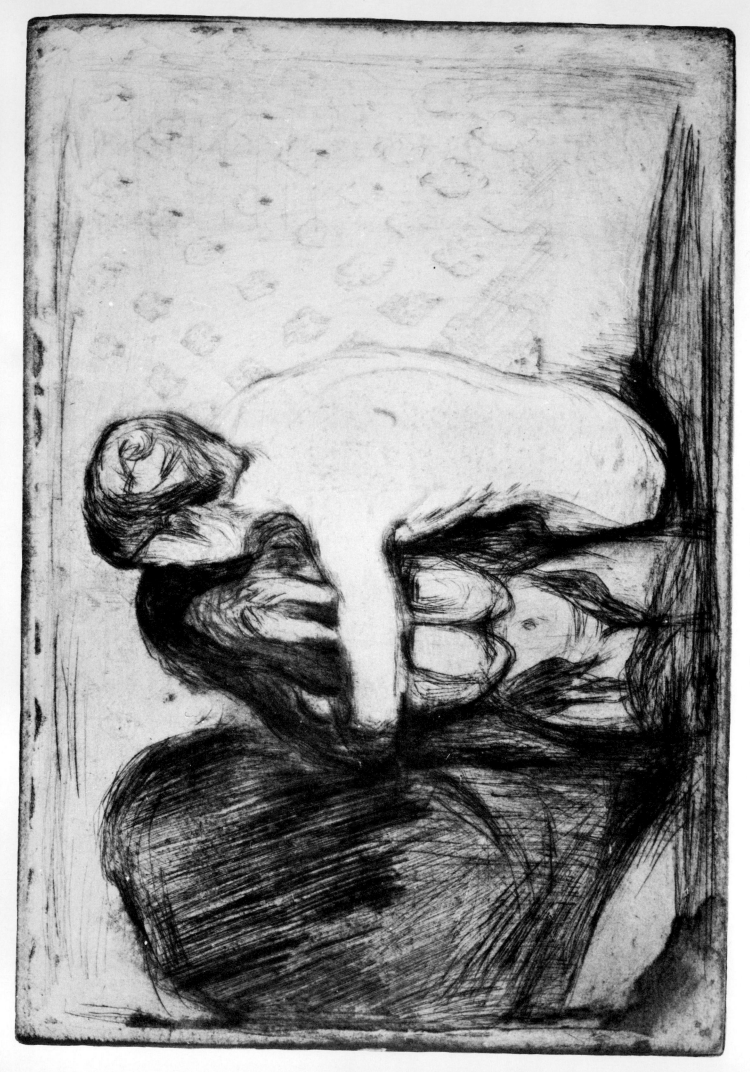

6 Consolation. 1894. Drypoint and aquatint.

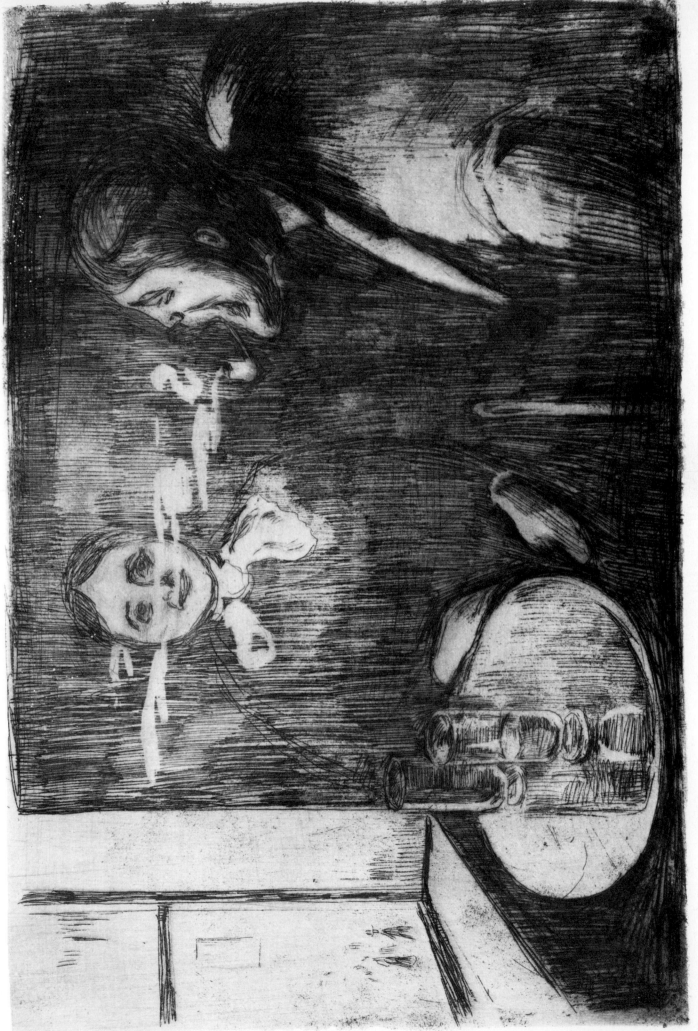

7 TÊTE-À-TÊTE. 1895. Etching.

8 CHRISTIANIA BOHEMIANS, I. 1895. Etching and aquatint.

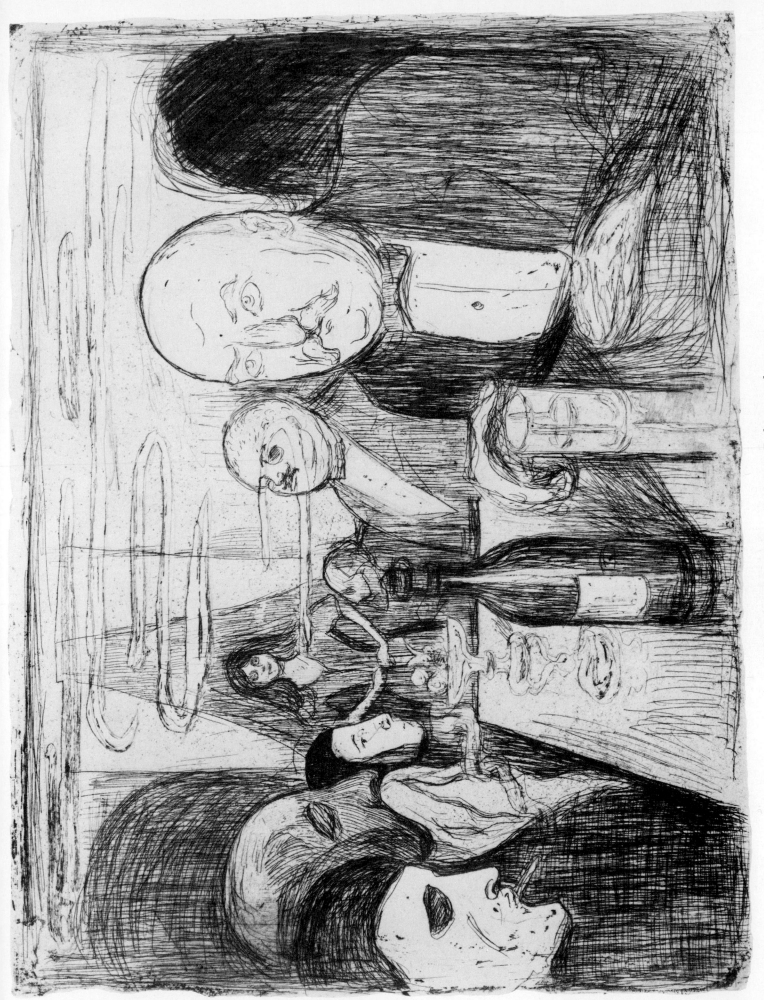

9 CHRISTIANIA BOHEMIANS, II. 1895. Etching and aquatint.

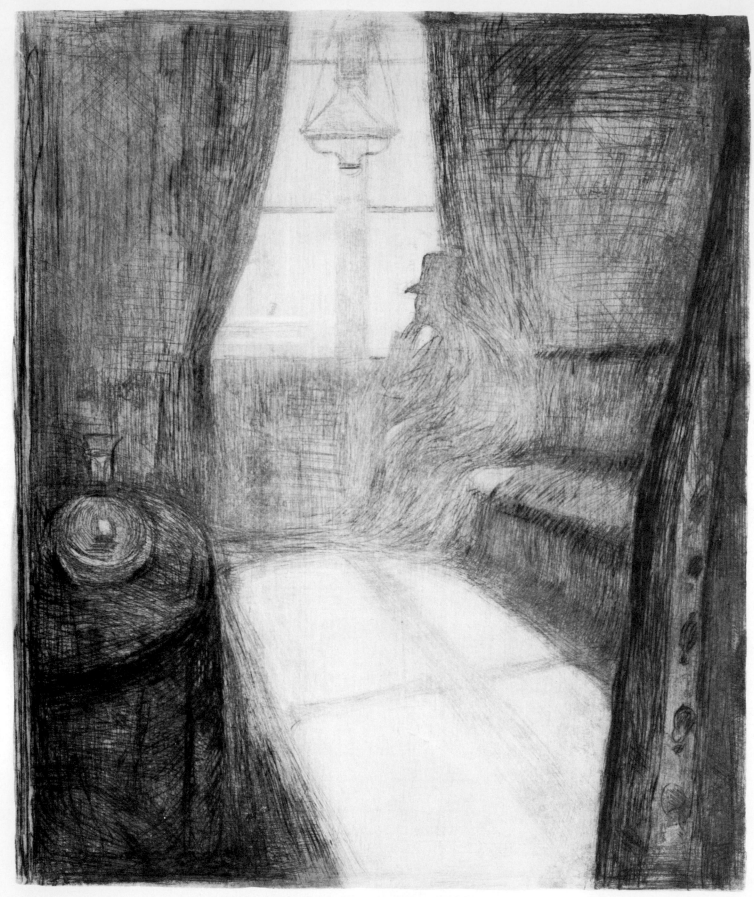

10 Moonlight. 1895. Drypoint and aquatint.

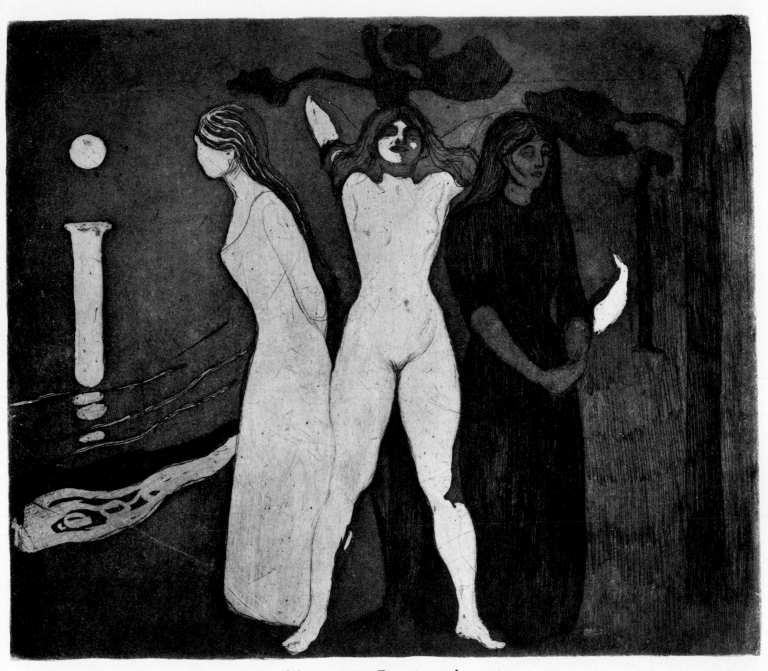

11 WOMAN. 1895. Drypoint and aquatint.

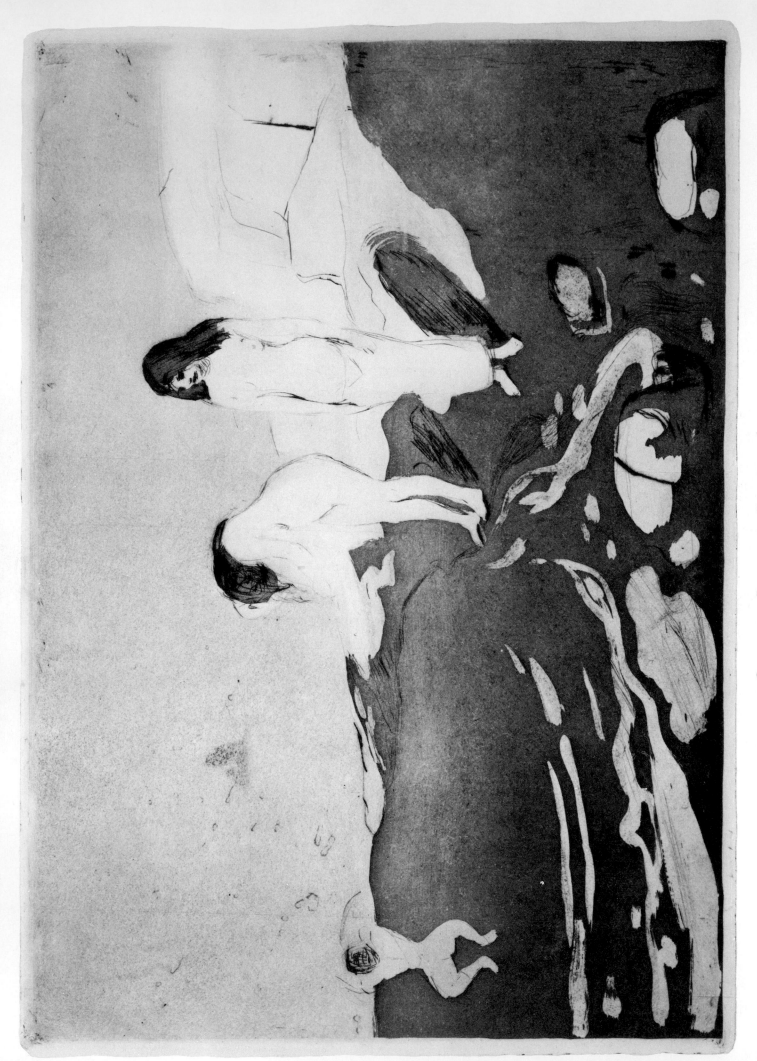

12 GIRLS ON THE BEACH. 1895. Drypoint and aquatint.

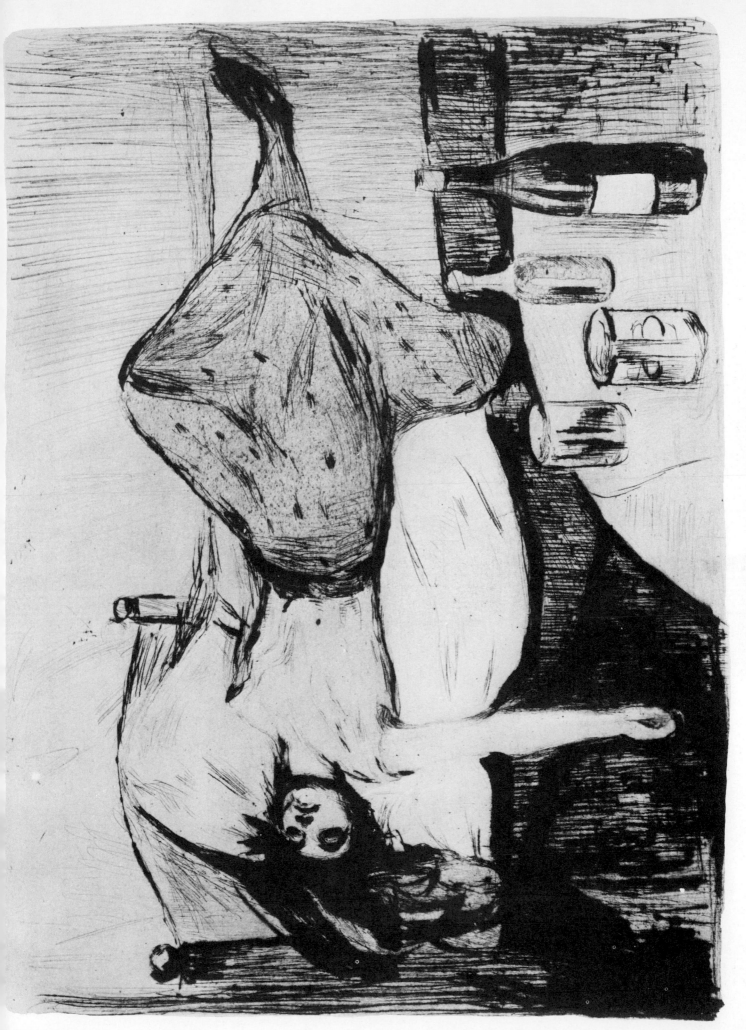

13 THE DAY AFTER. 1895. Drypoint and aquatint.

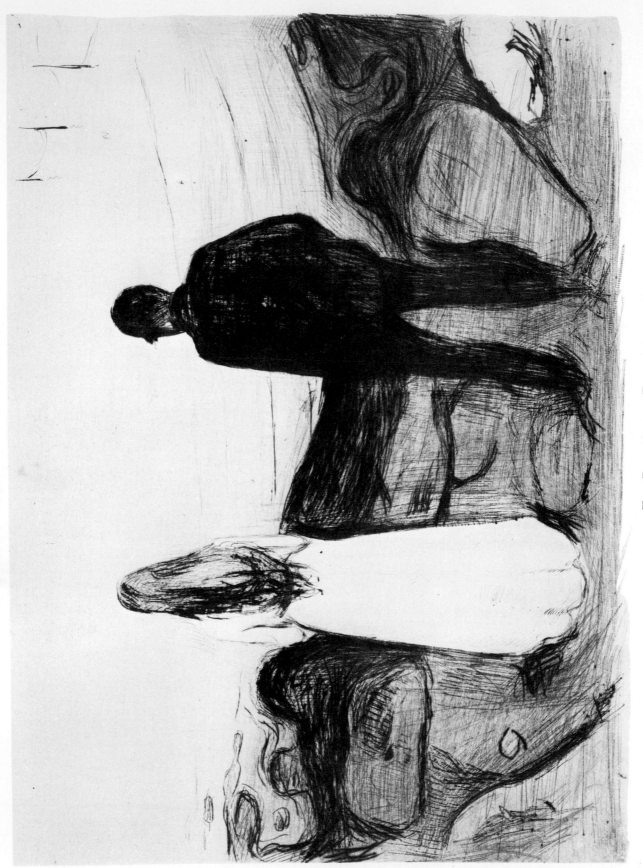

14 Two People. 1895. Drypoint.

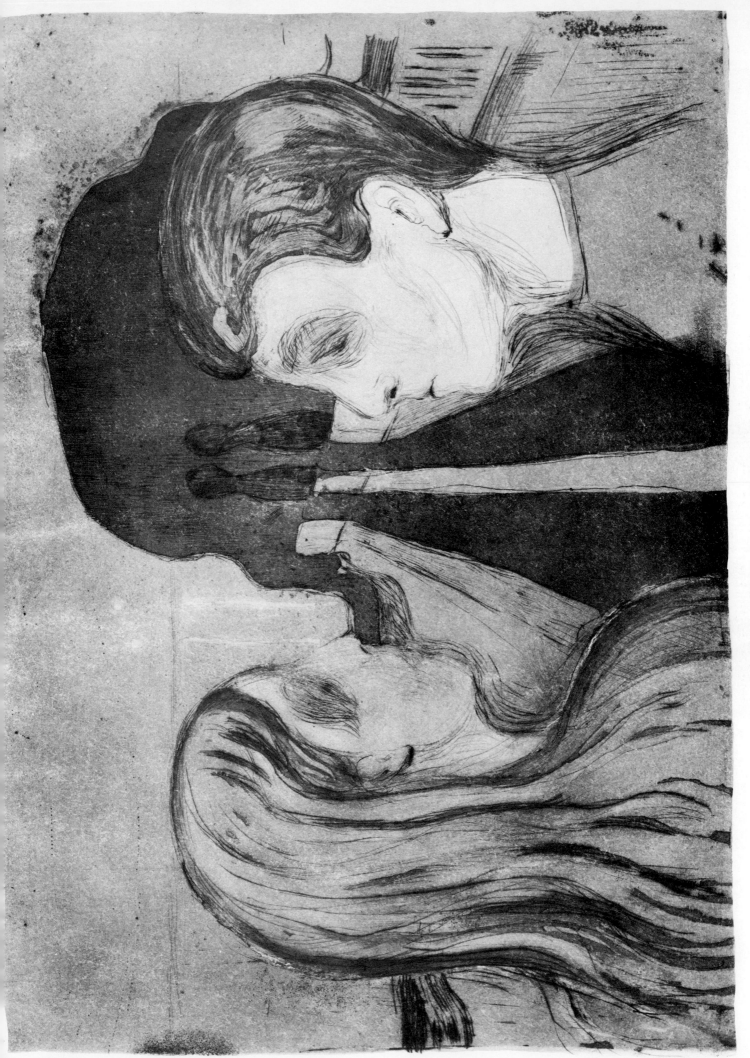

15 Lovers on the Beach, II. 1895. Etching and drypoint.

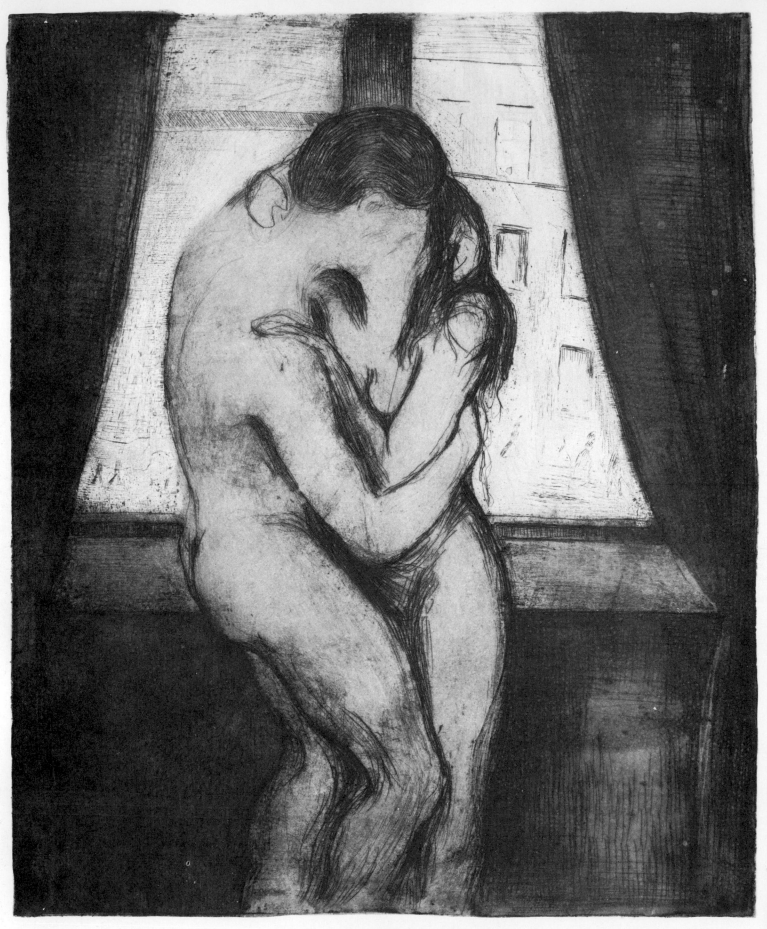

16 THE KISS. 1895. Drypoint and aquatint.

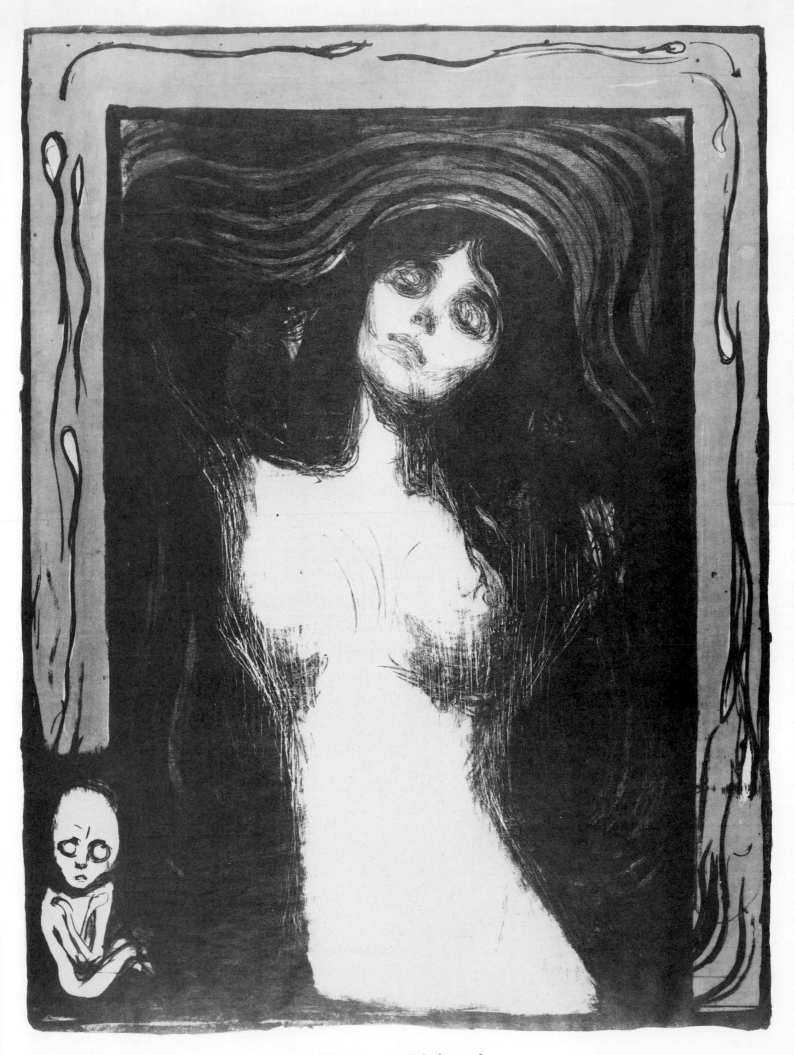

17 MADONNA. 1895. Lithograph.

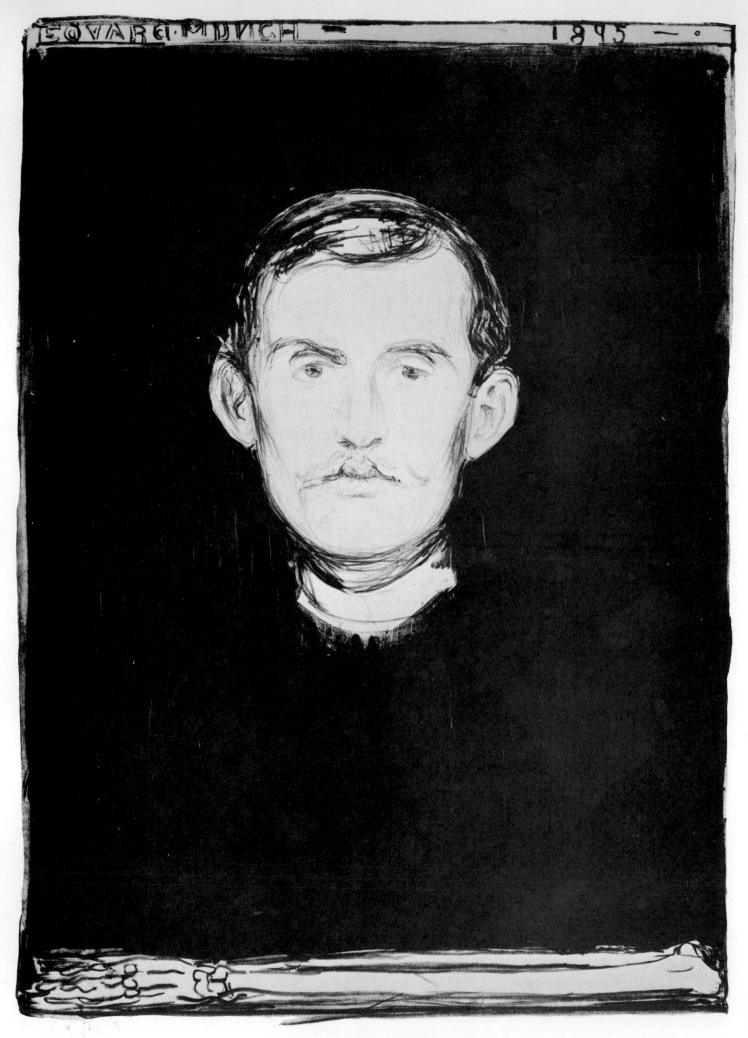

18 SELF-PORTRAIT. 1895. Lithograph.

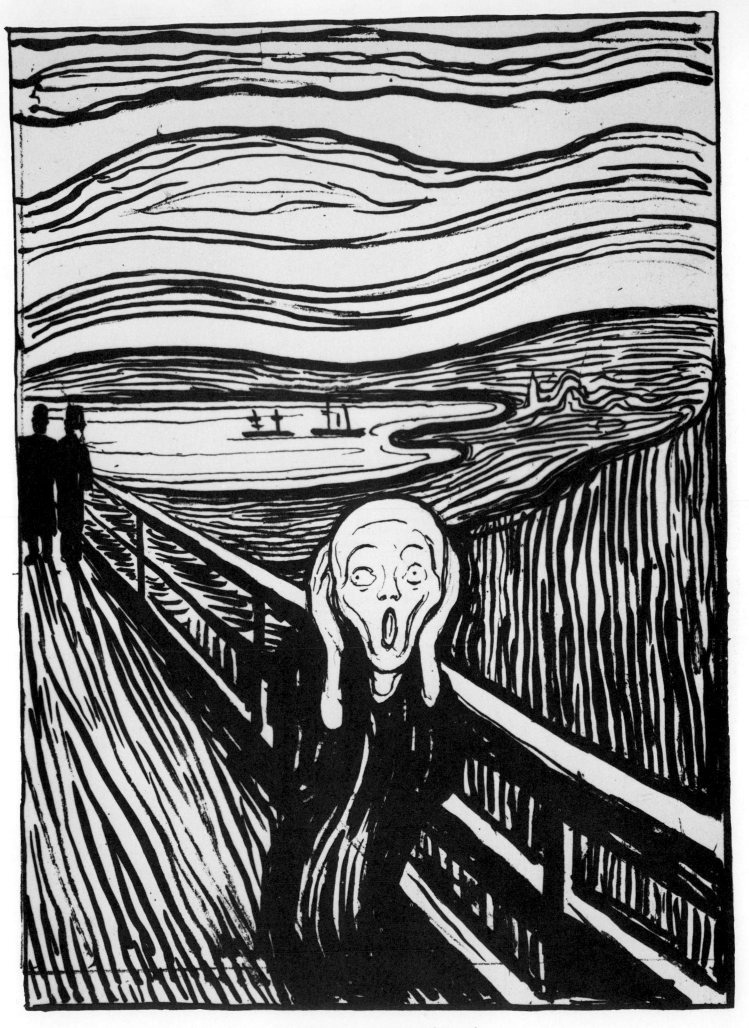

19 THE SCREAM. 1895. Lithograph.

20 SUMMER NIGHT. 1895. Drypoint and aquatint.

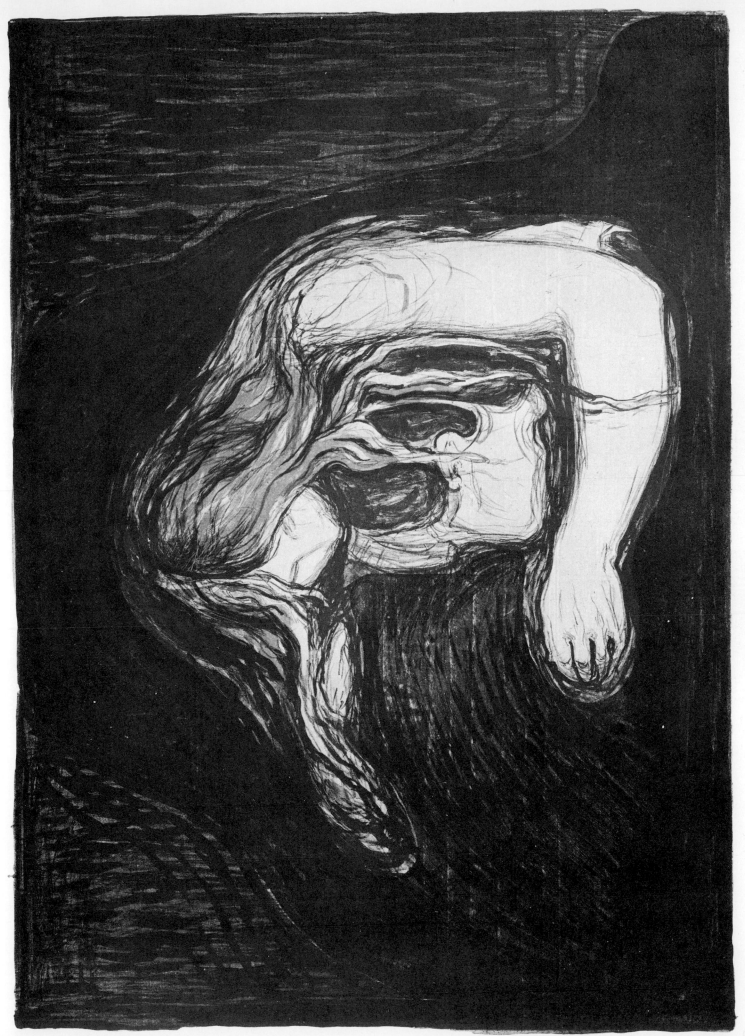

21　The Vampire. 1895. Woodcut and lithograph.

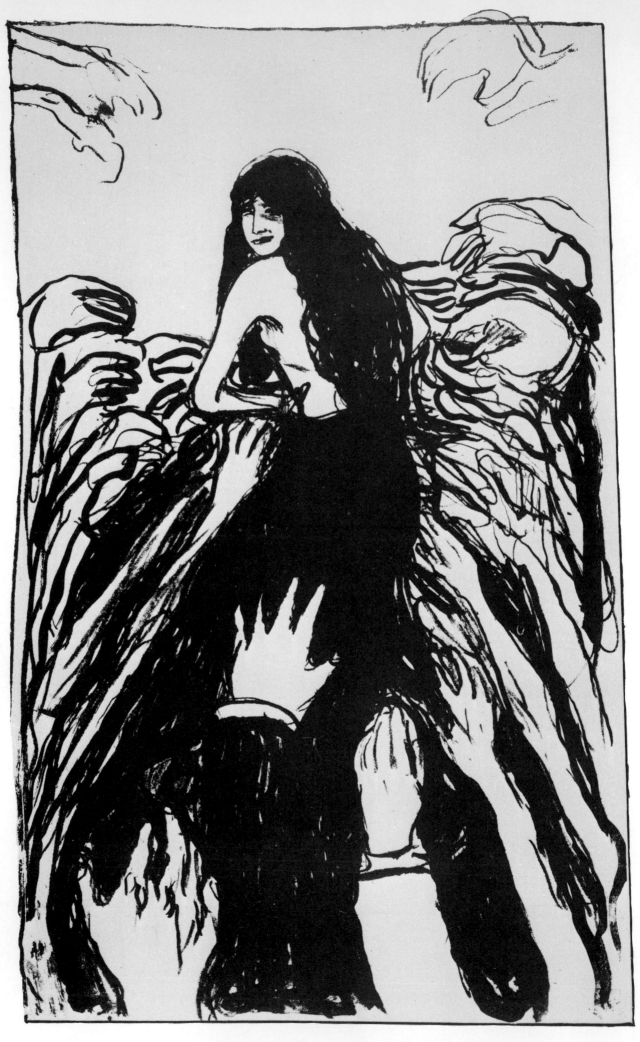

22 DESIRE FOR WOMAN. 1895. Lithograph.

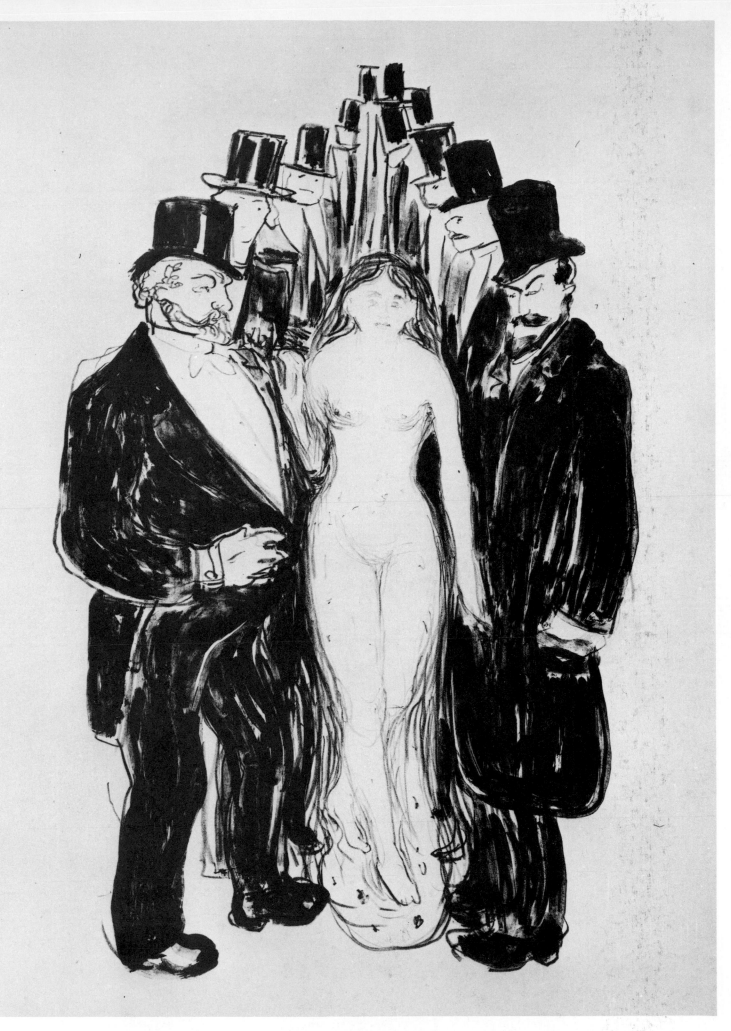

23 THE LANE. 1895. Lithograph.

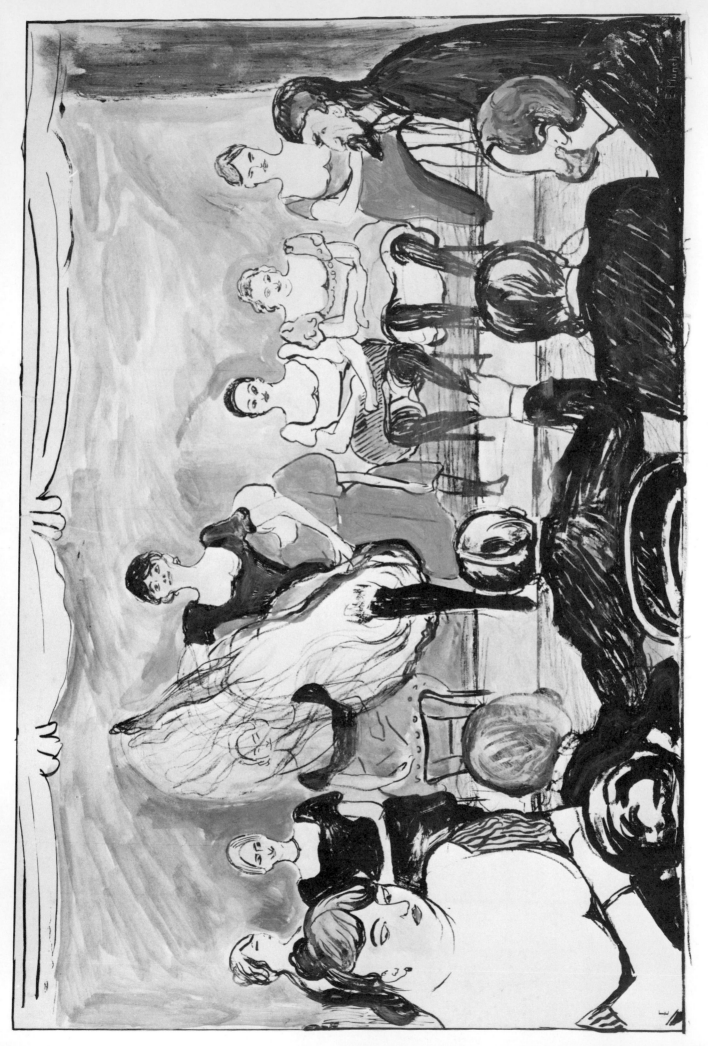

24 The Cabaret. 1895. Lithograph.

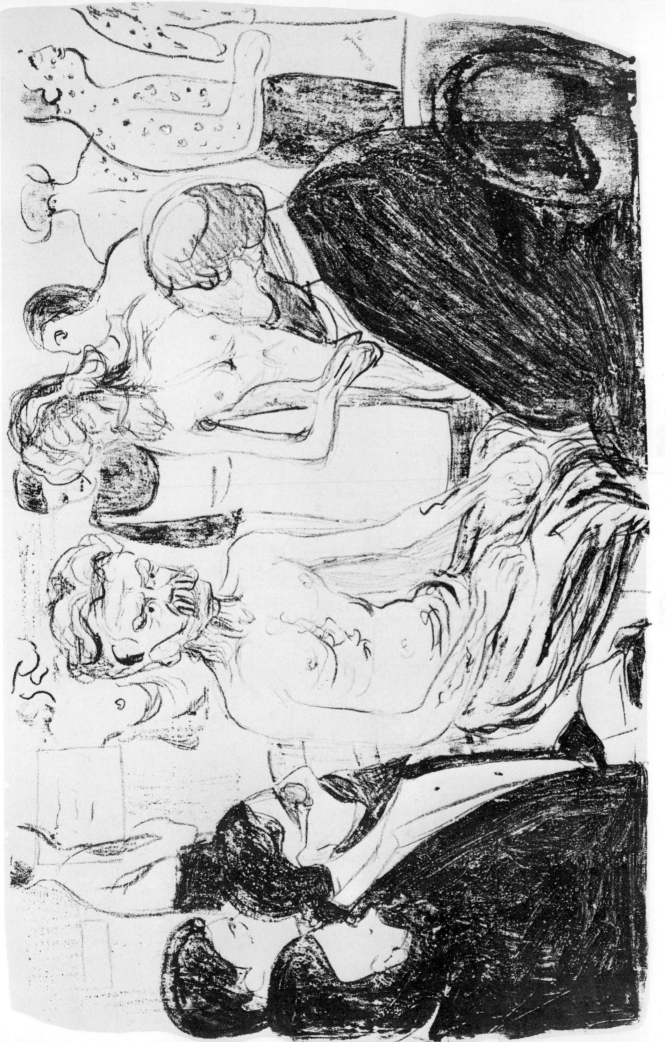

25 At the Clinic. 1896. Lithograph.

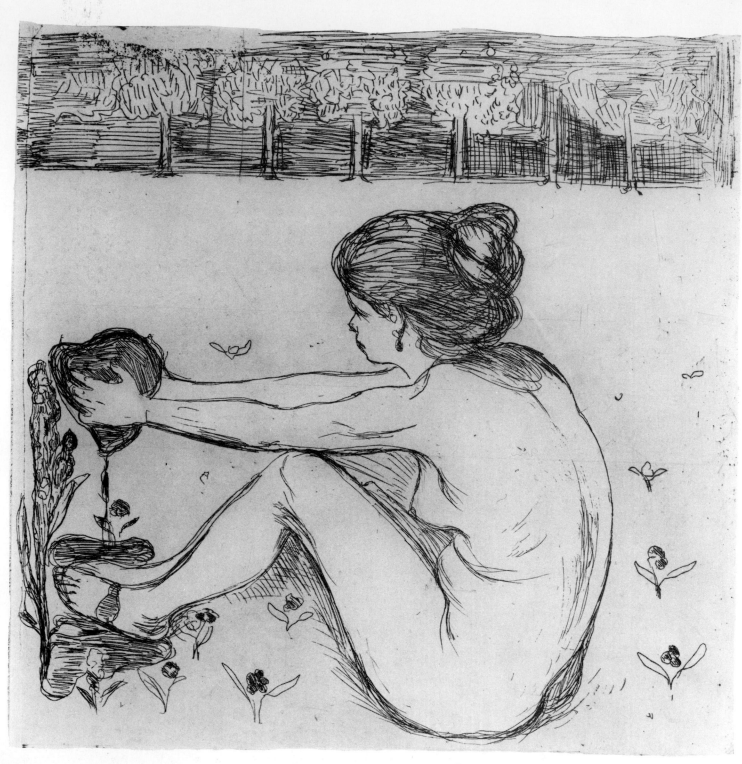

26 GIRL WITH HEART. 1896. Etching.

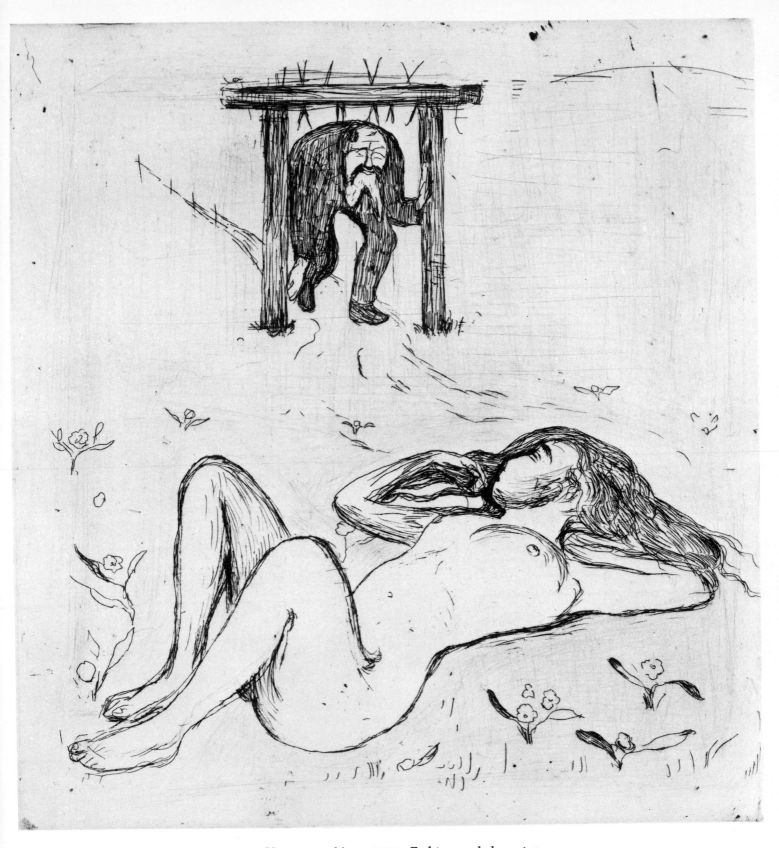

27 UNDER THE YOKE. 1896. Etching and drypoint.

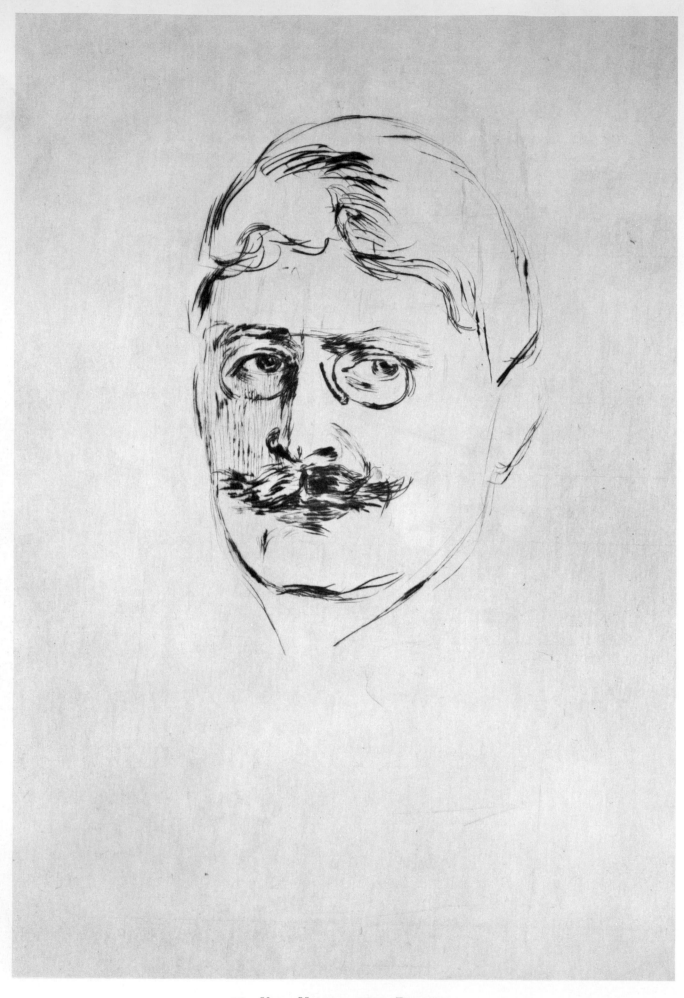

28 KNUT HAMSUN. 1896. Drypoint.

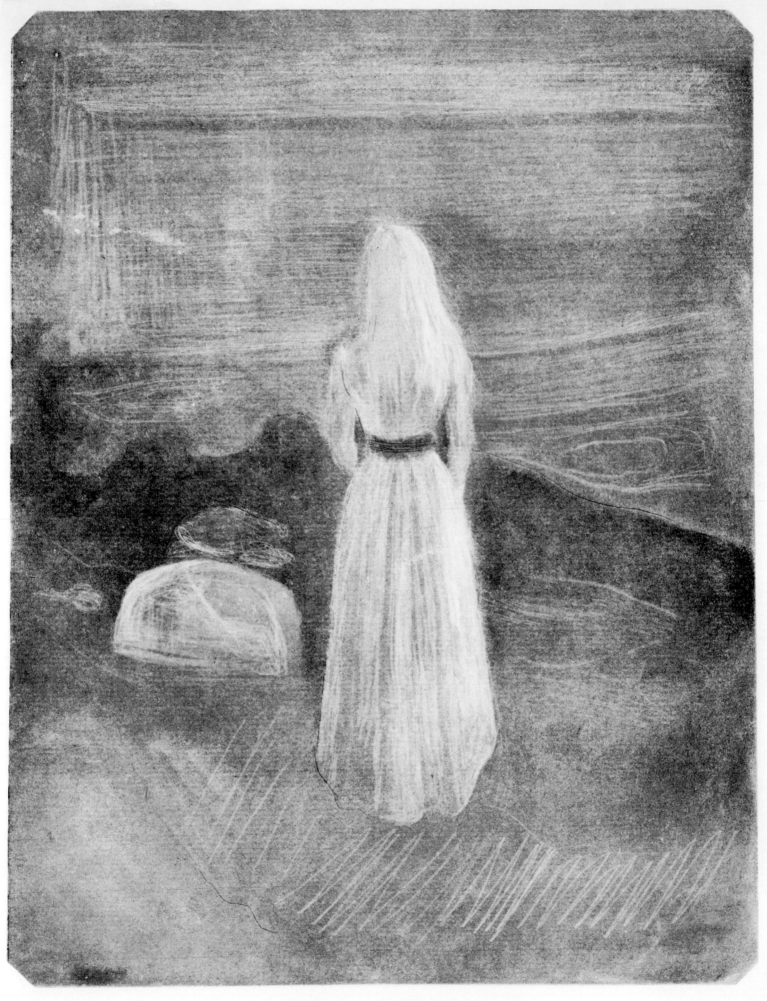

29 YOUNG GIRL AT THE SHORE. 1896. Mezzotint.

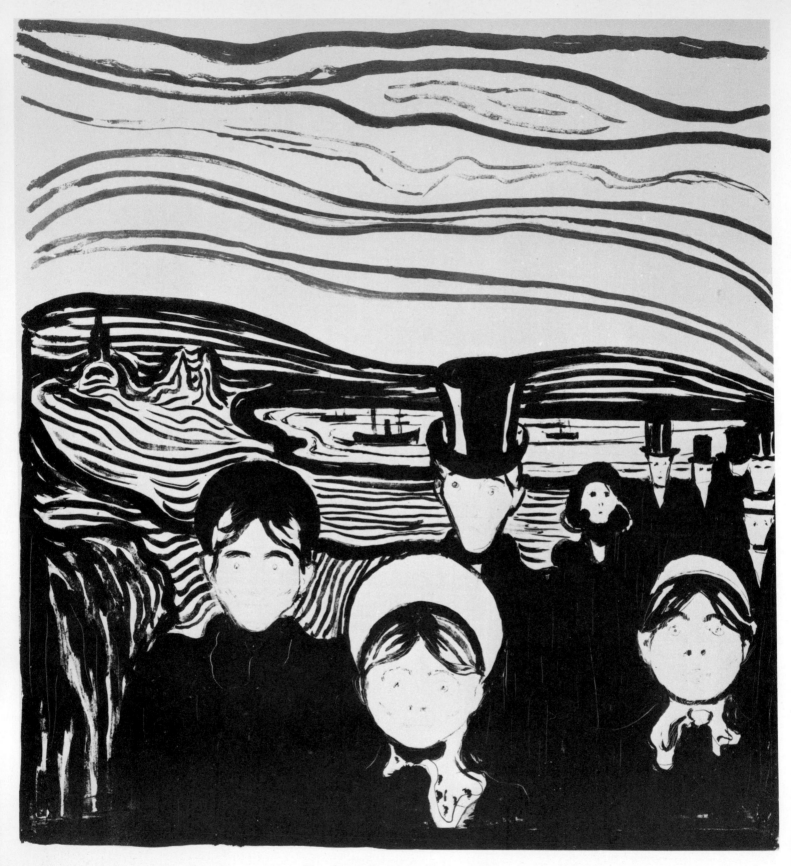

30 ANXIETY. 1896. Lithograph.

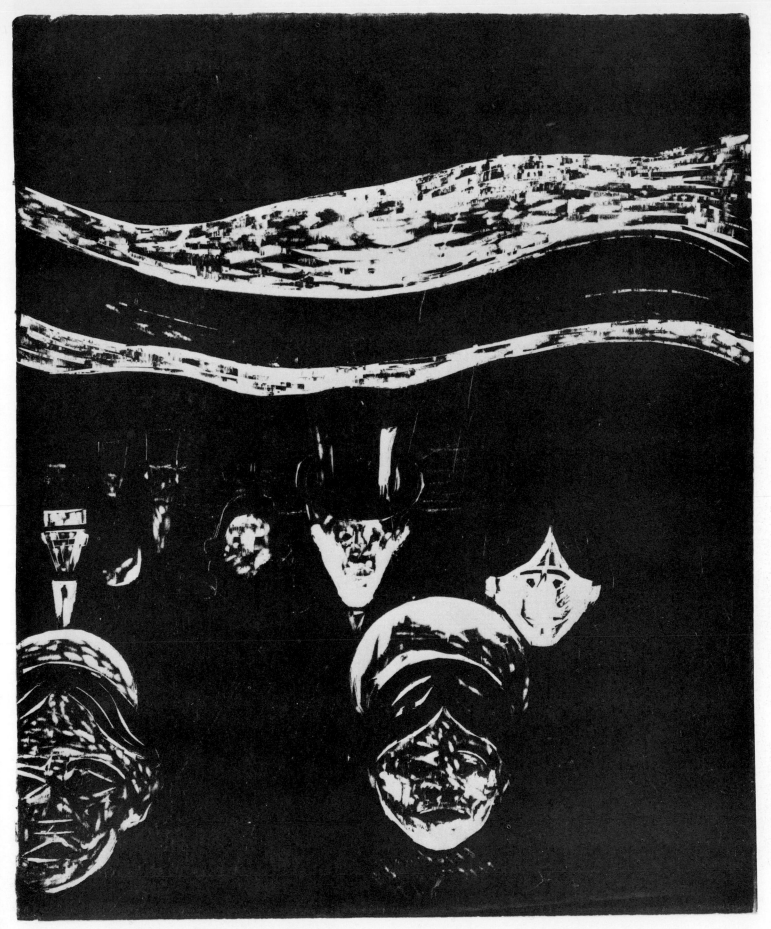

31 ANXIETY. 1896. Woodcut.

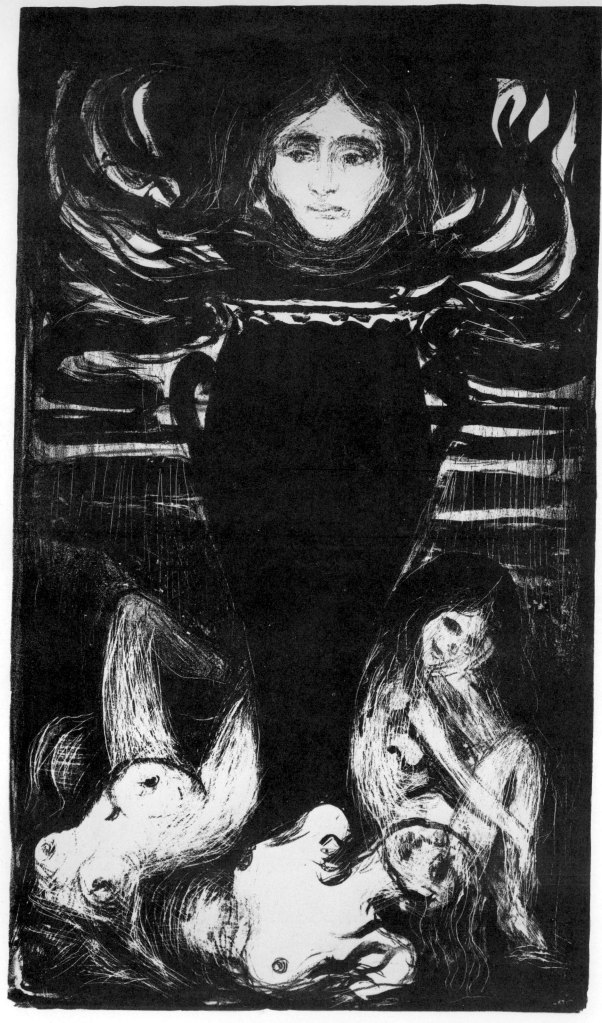

32 THE URN. 1896. Lithograph.

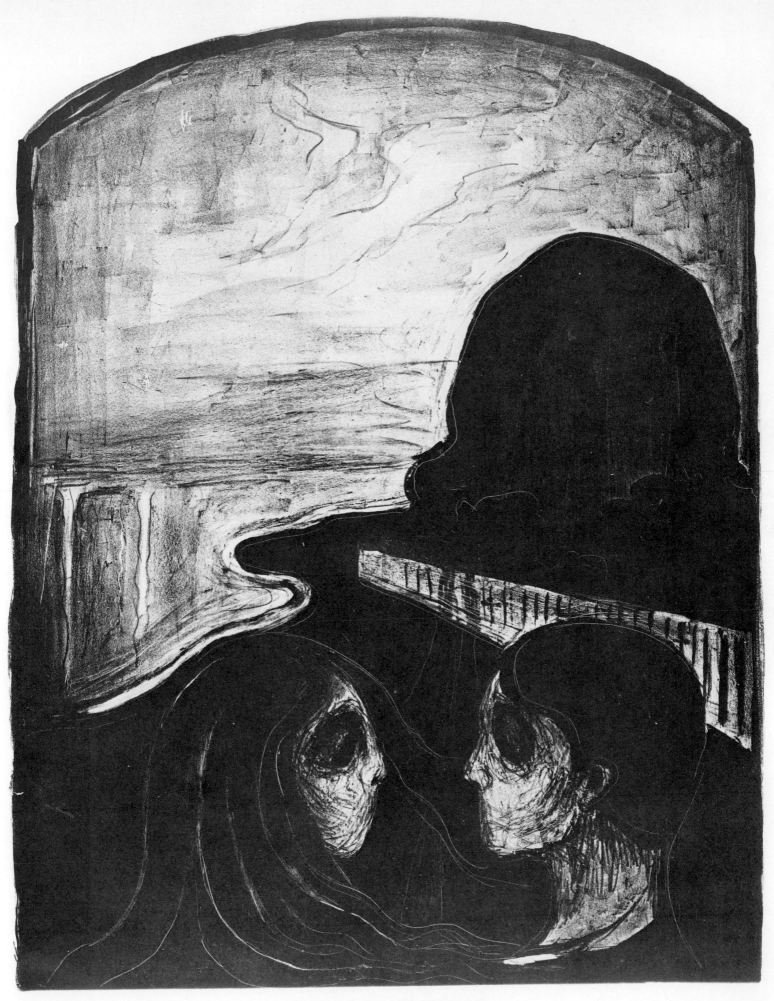

33 ATTRACTION. 1896. Lithograph.

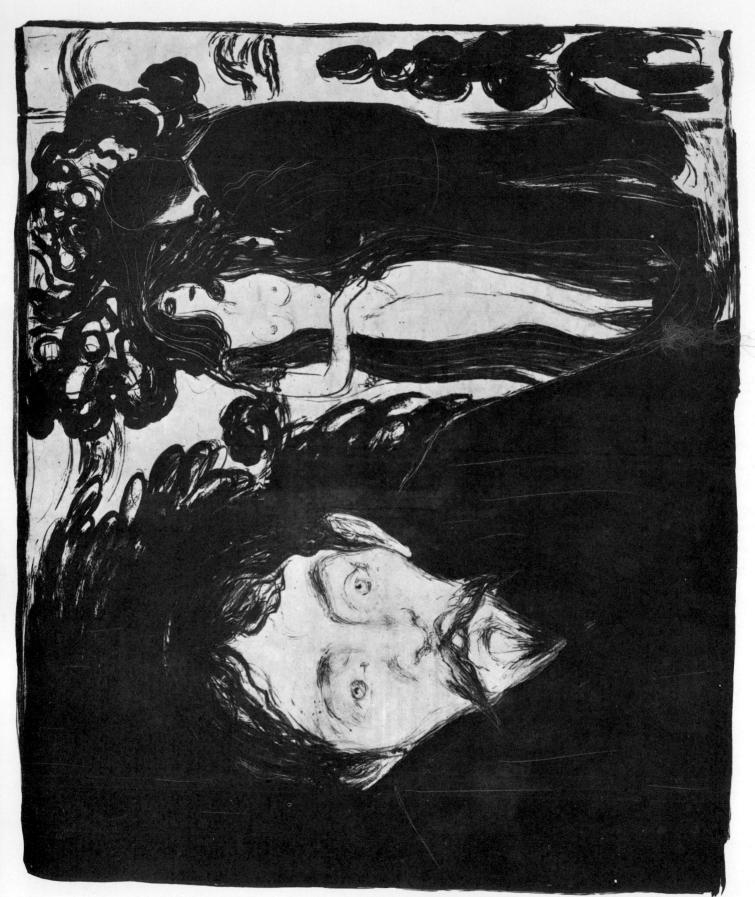

34 JEALOUSY. 1896. Lithograph.

35 LOVERS. 1896. Lithograph.

36 DEATH CHAMBER. 1896. Lithograph.

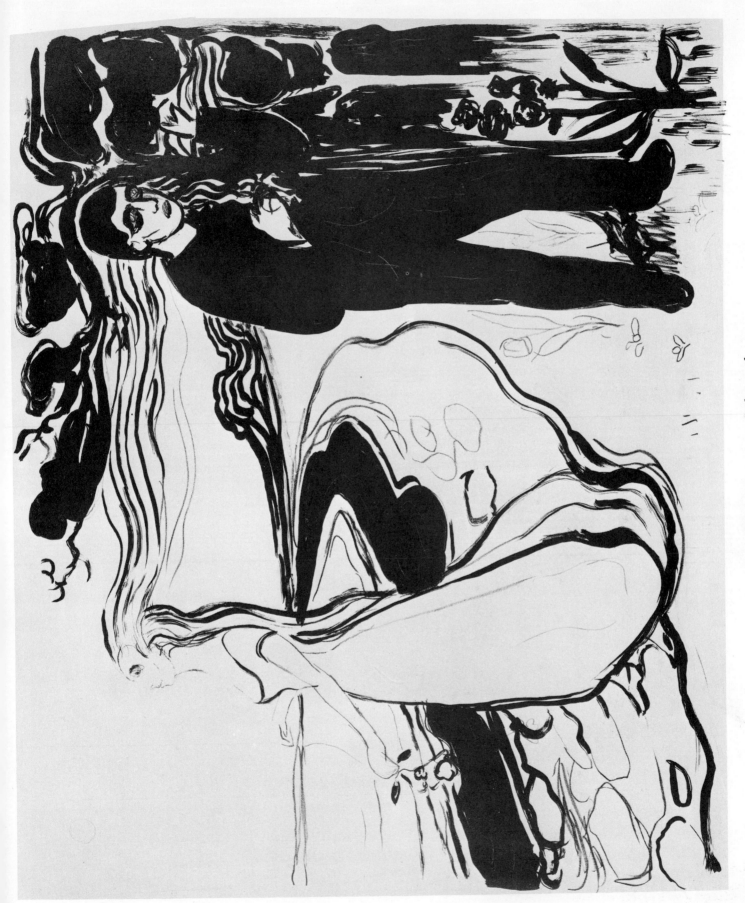

37 SEPARATION. 1896. Lithograph.

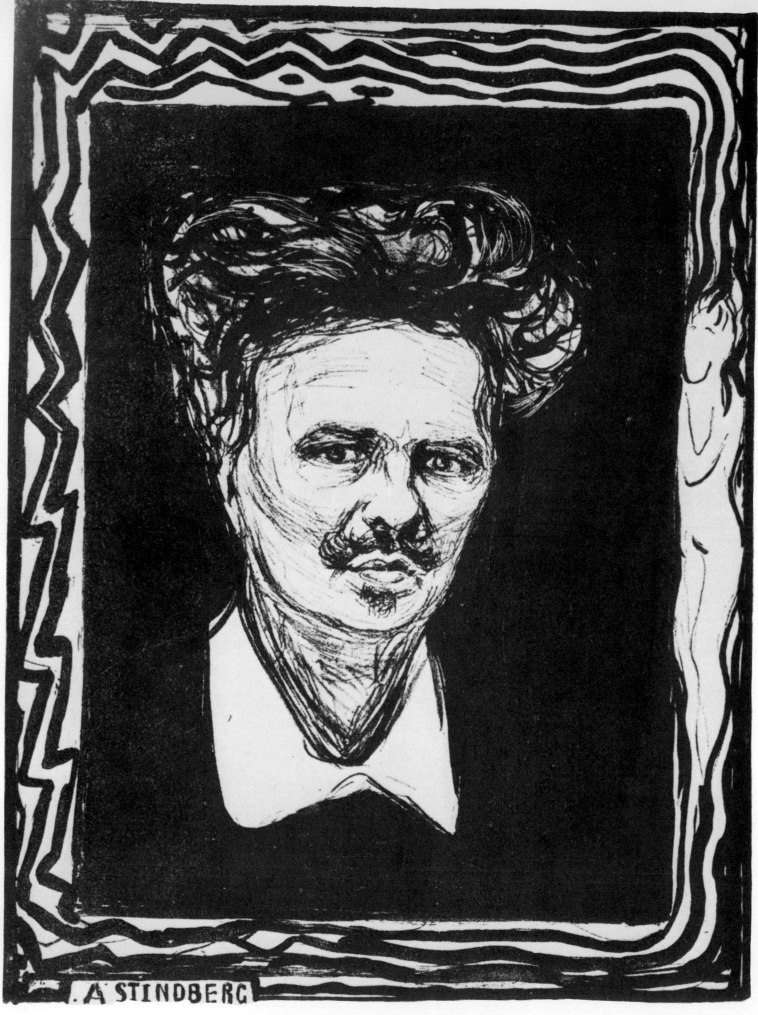

38 AUGUST STRINDBERG. 1896. Lithograph.

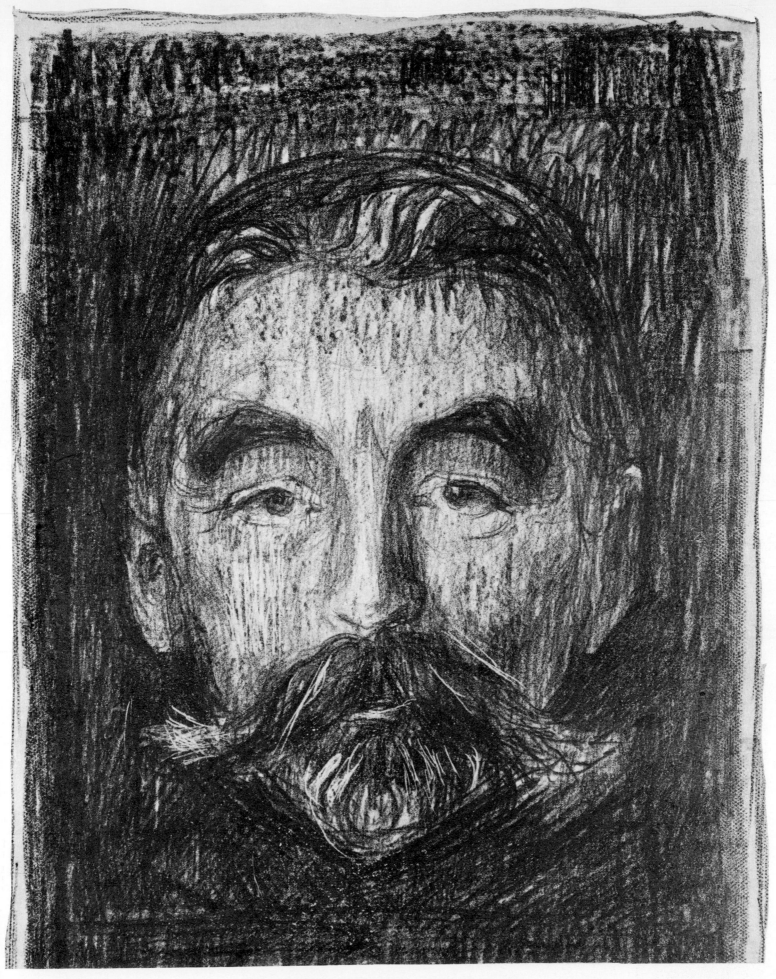

39 Stéphane Mallarmé. 1896. Lithograph.

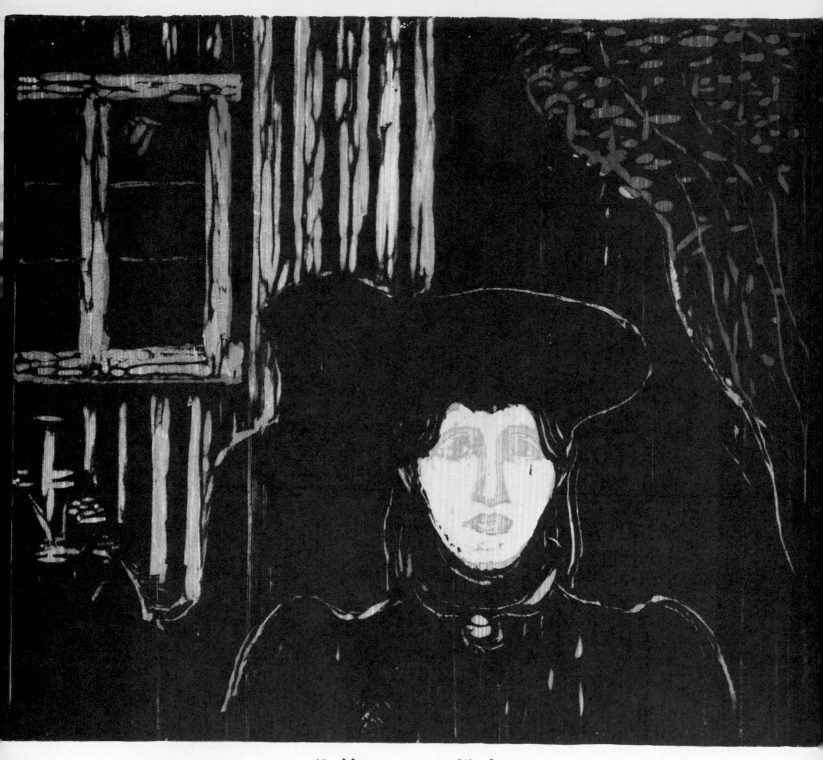

40 Moonlight. 1896. Woodcut.

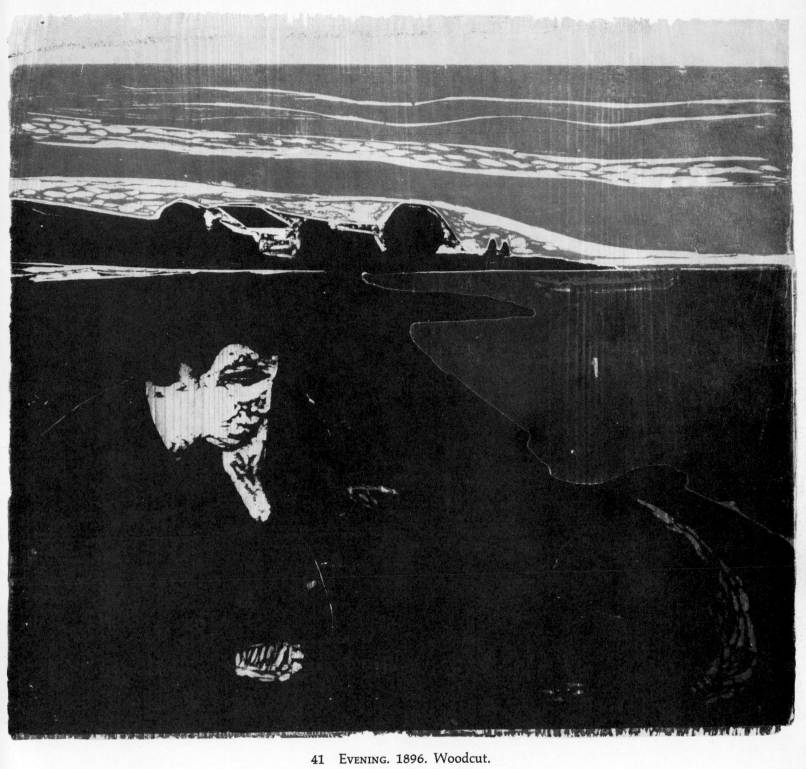

41 EVENING. 1896. Woodcut.

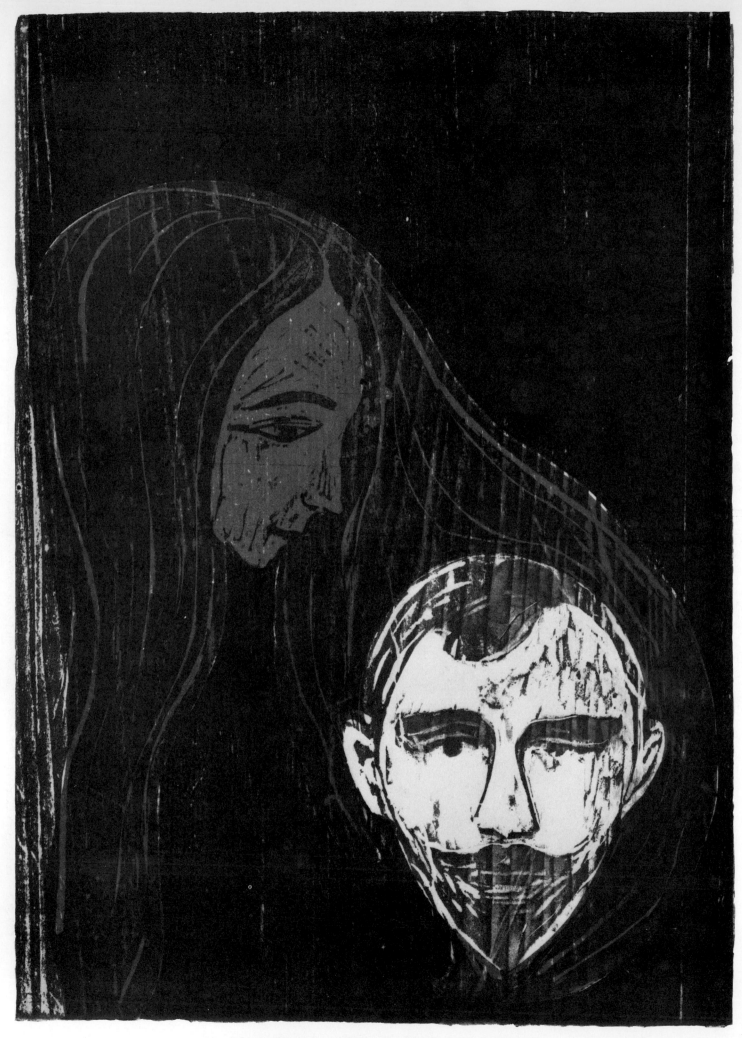

42 MAN'S HEAD IN A WOMAN'S HAIR. 1896. Woodcut.

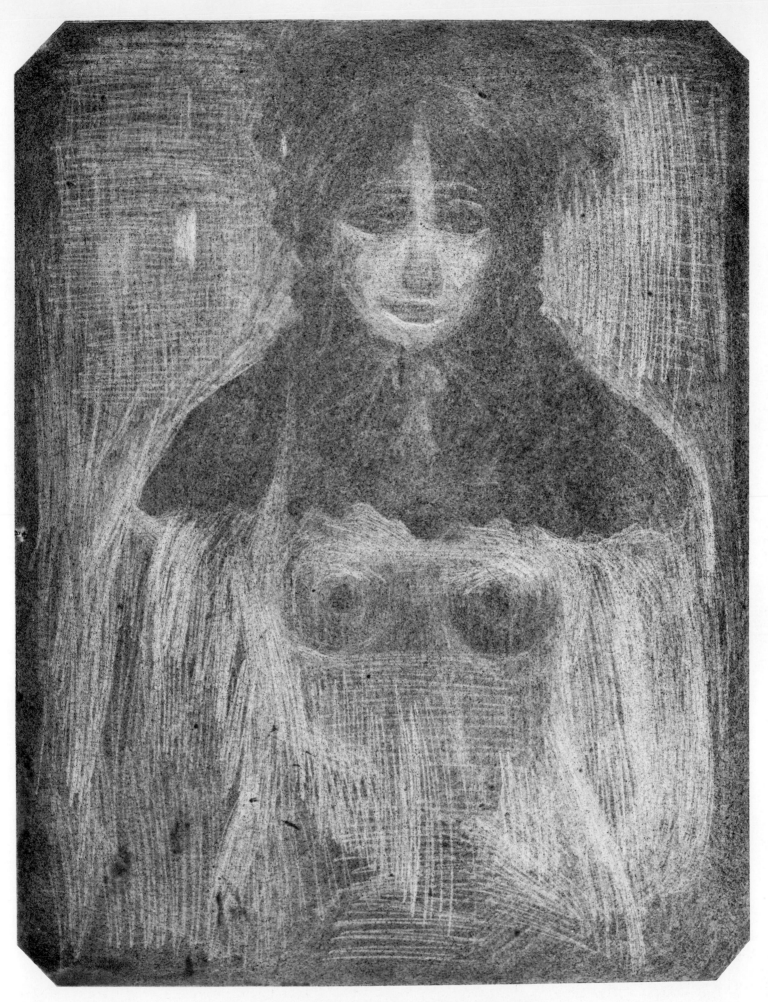

43 MODEL WITH HOOD AND COLLAR. 1897. Mezzotint.

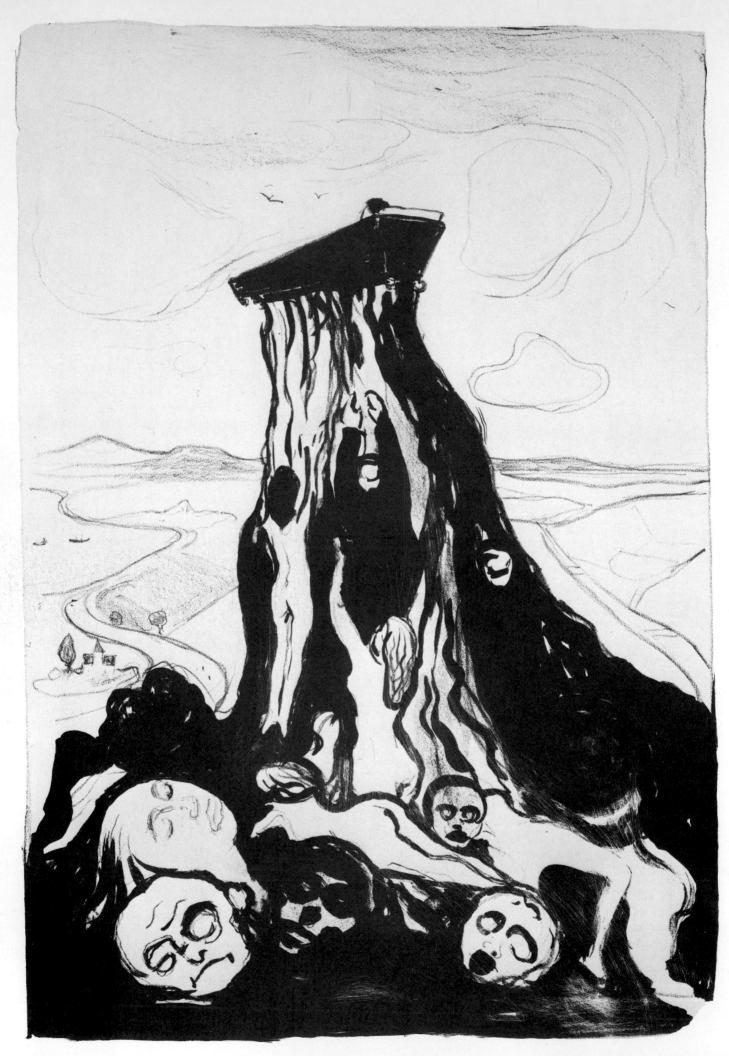

44 FUNERAL MARCH. 1897. Lithograph.

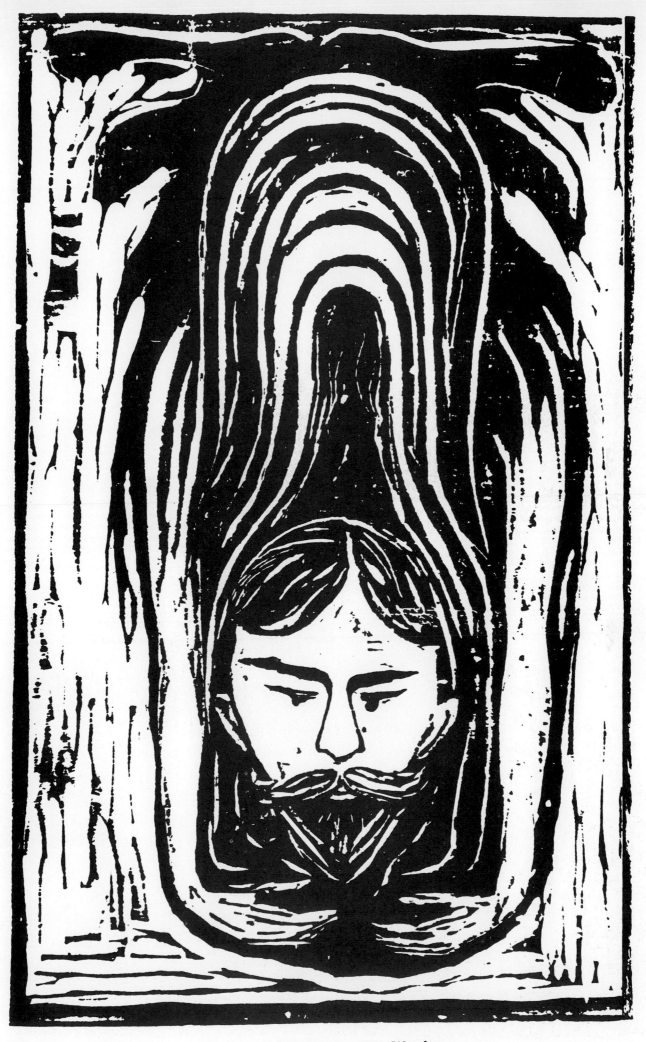

45 Salome Paraphrase. 1898. Woodcut.

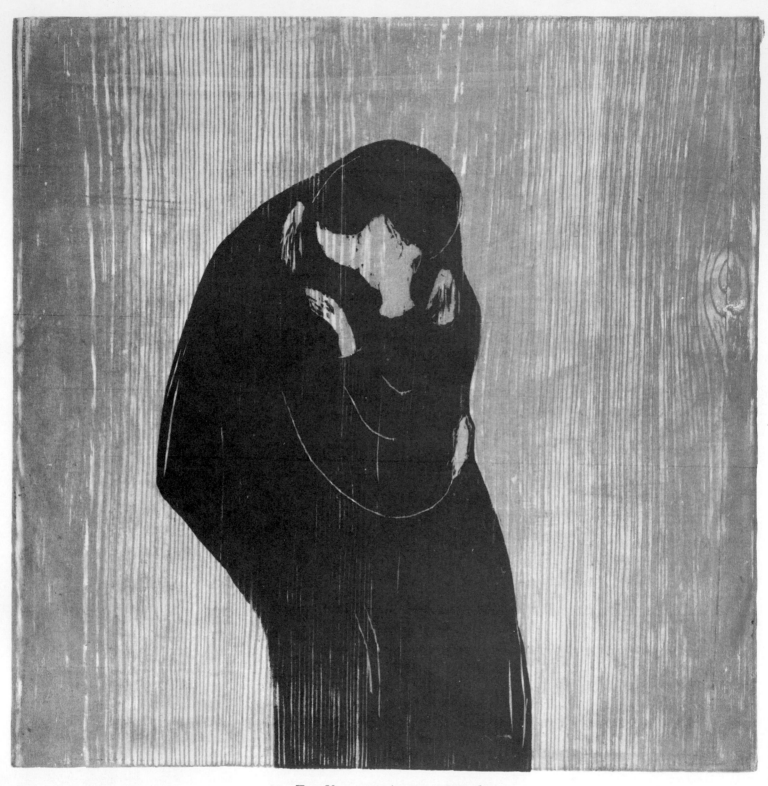

46 THE KISS. 1897/8–1902. Woodcut.

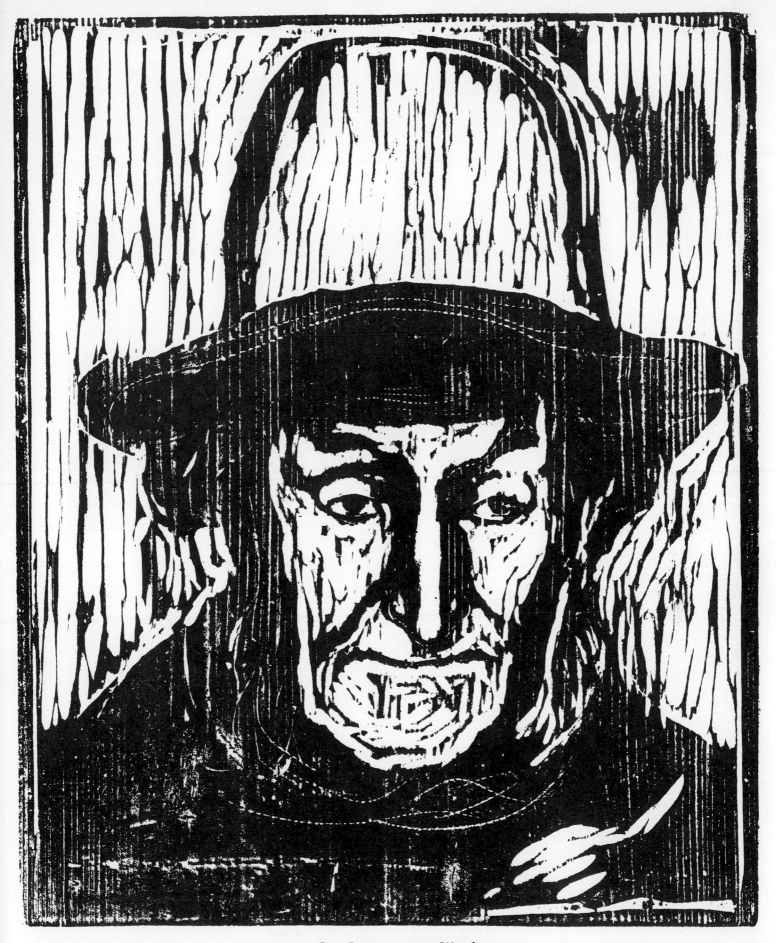

47 OLD SEAMAN. 1899. Woodcut.

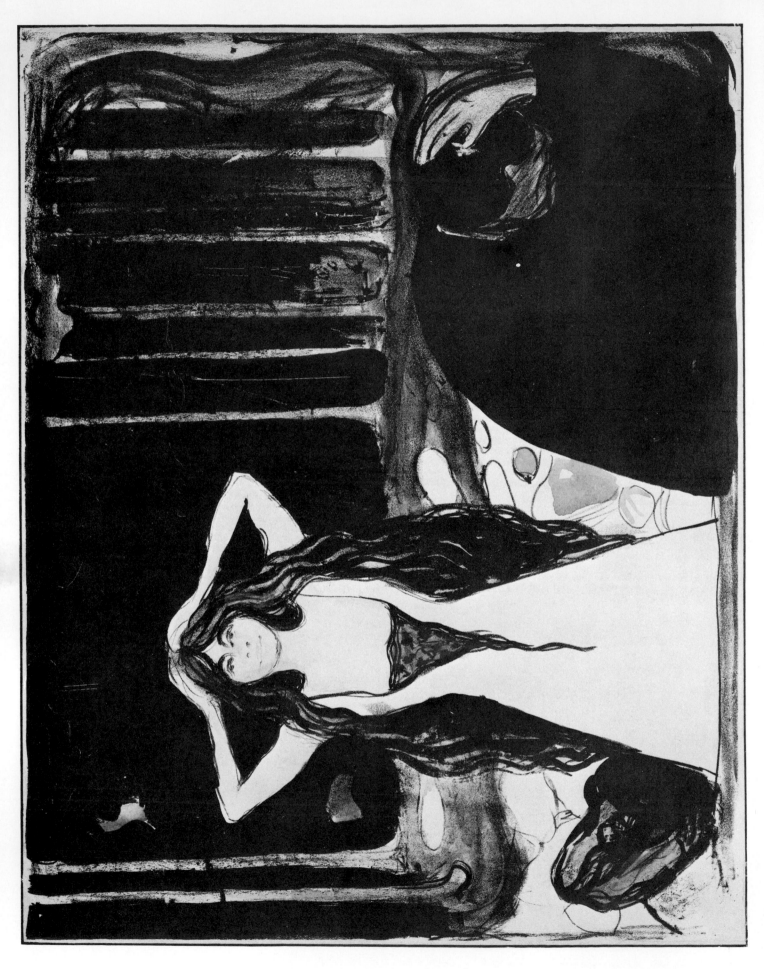

48 Ashes, II. 1899. Lithograph.

49 *Woman.* 1899. Lithograph.

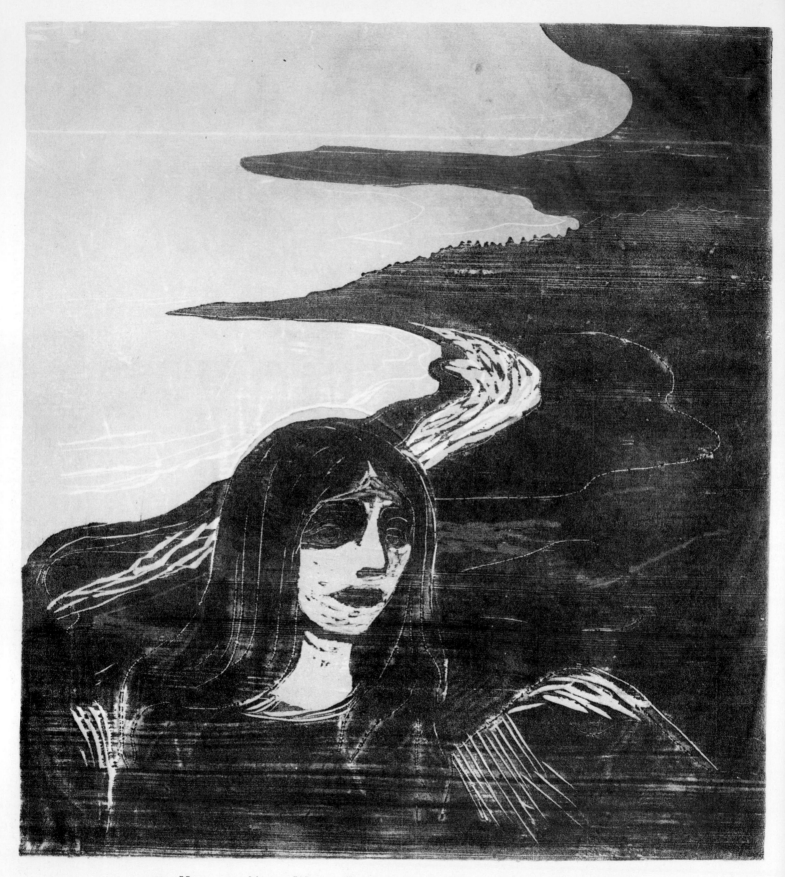

50 HEAD OF A YOUNG WOMAN SILHOUETTED AGAINST THE SHORE. 1899. Woodcut.

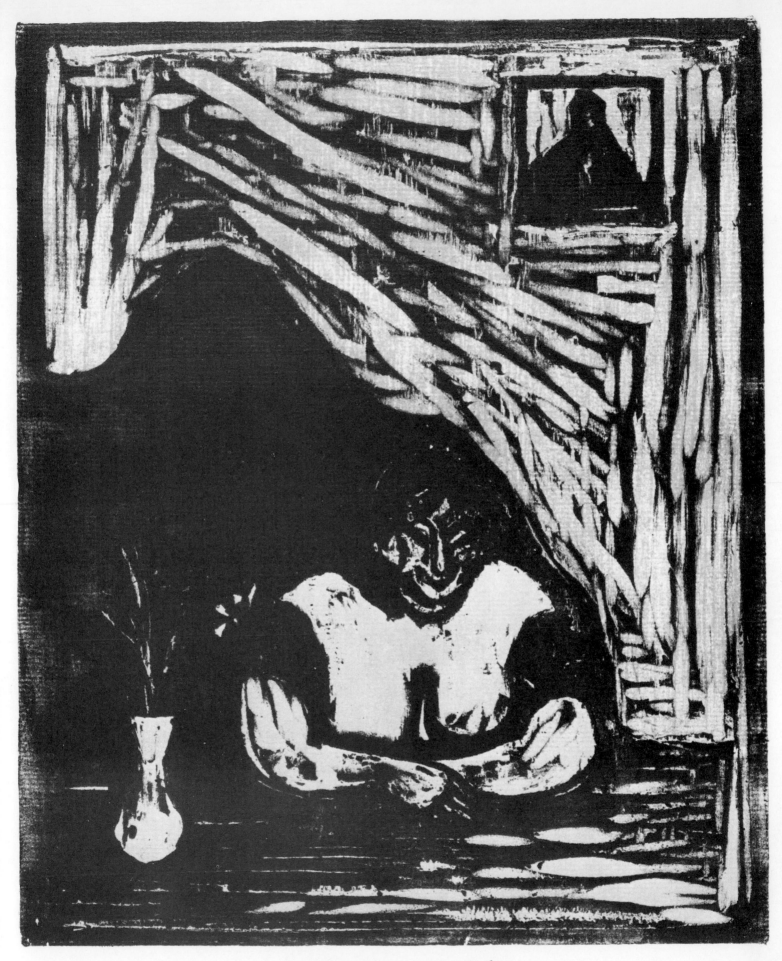

51 THE FAT HARLOT. 1899. Woodcut.

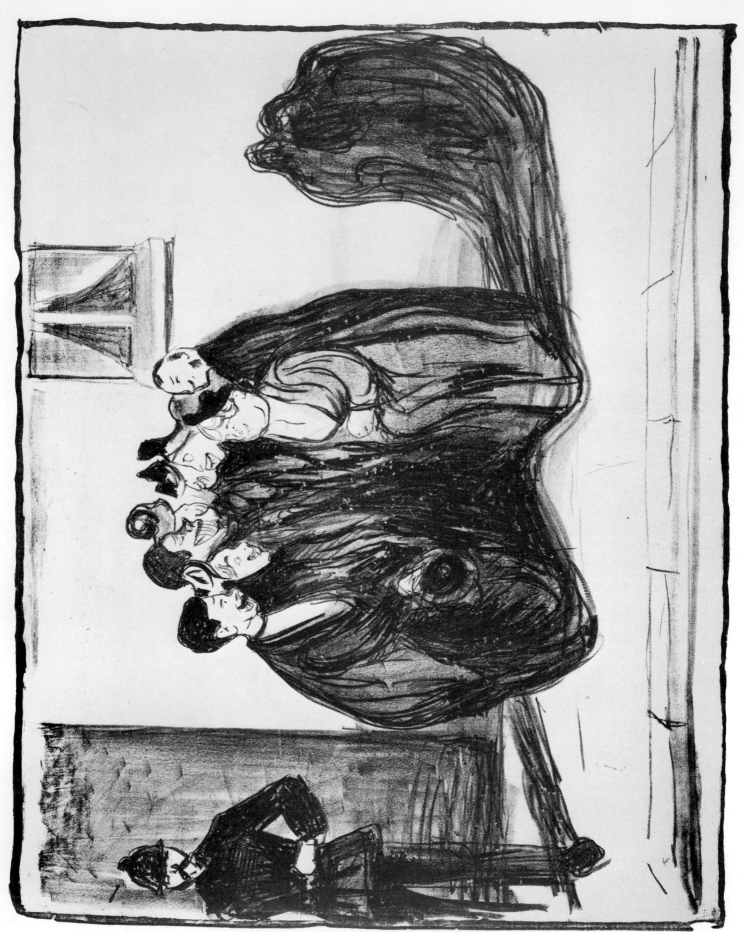

52 "We Enjoyed Your Company." 1899. Lithograph.

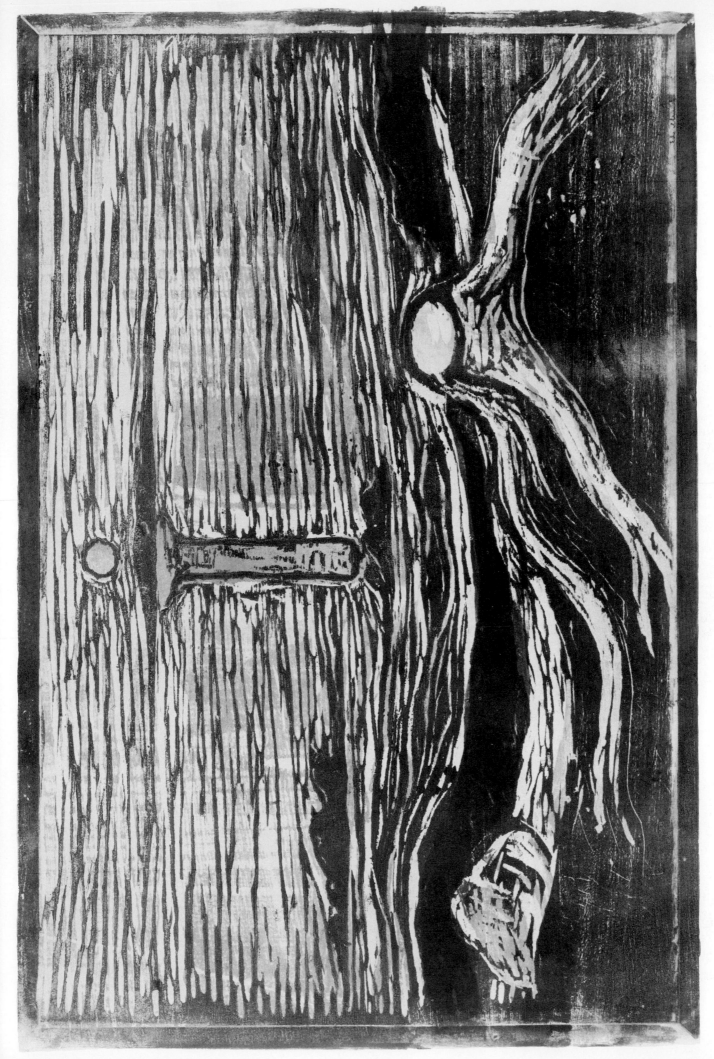

53 Seascape. 1899. Woodcut.

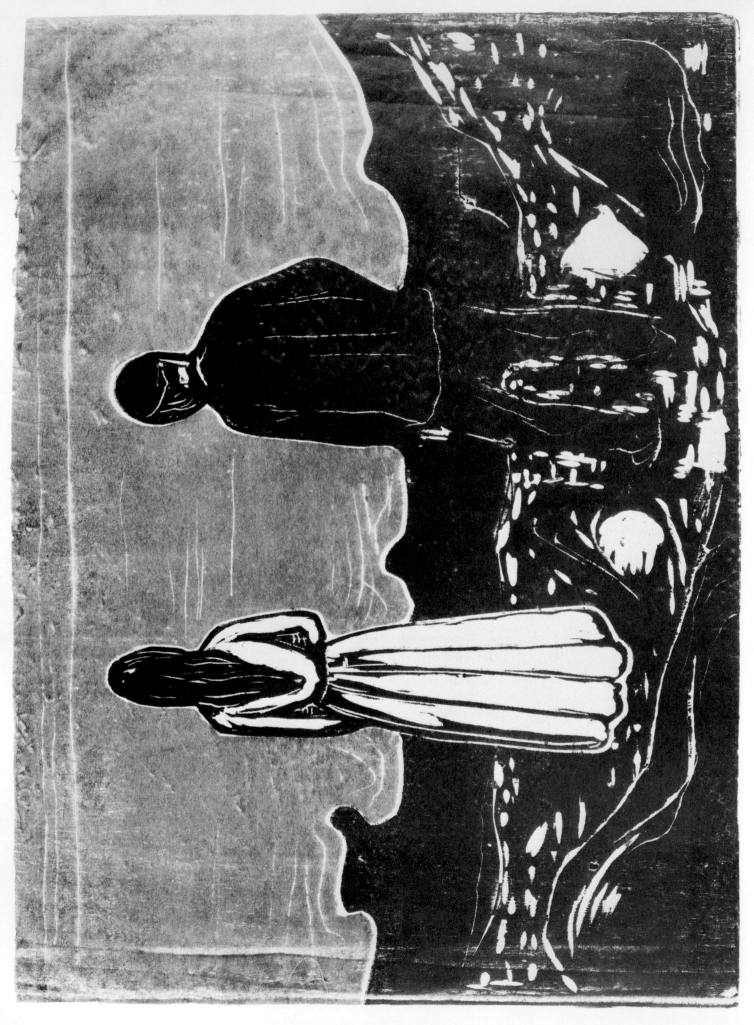

54 Two People. 1899. Woodcut.

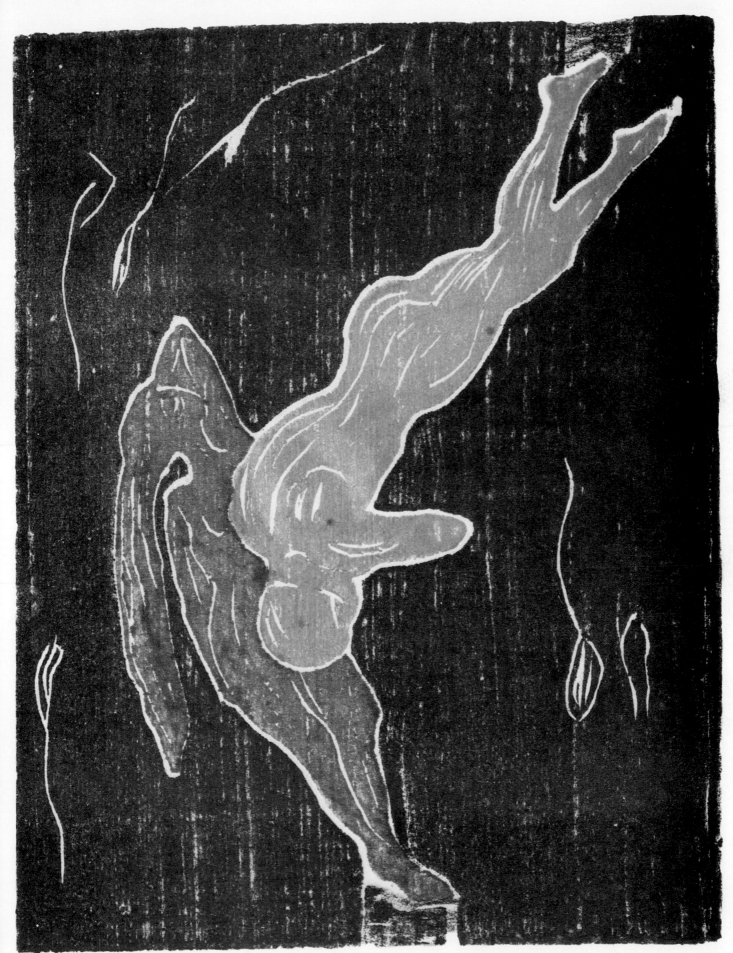

55 ENCOUNTER IN SPACE. 1899. Woodcut.

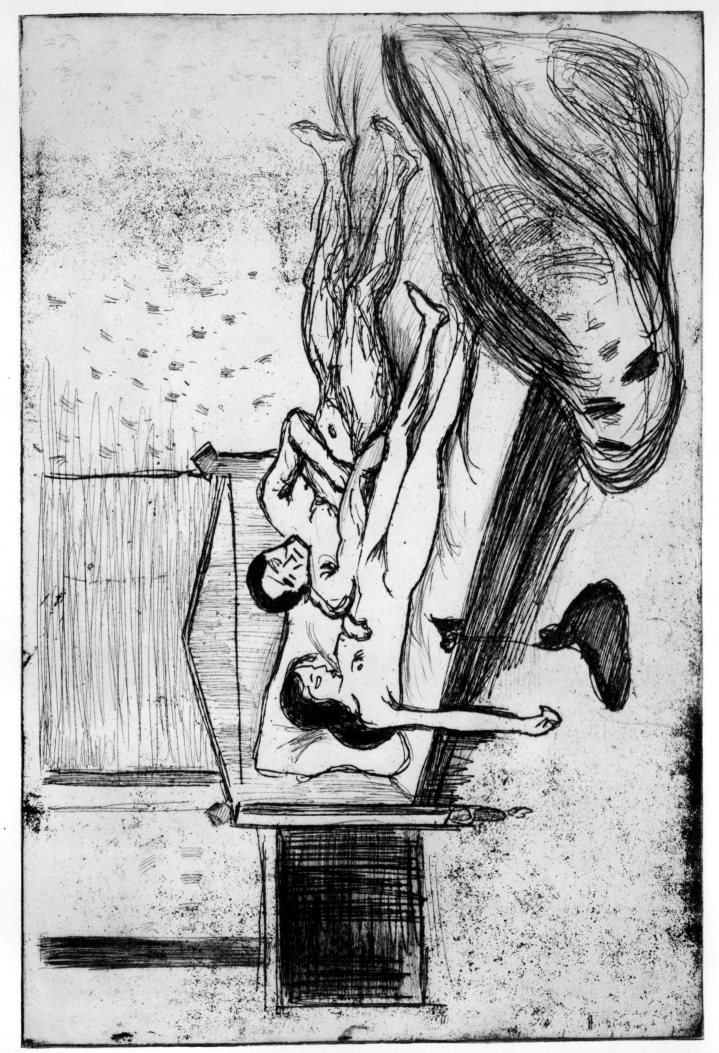

56 Dead Lovers. 1901. Etching and aquatint.

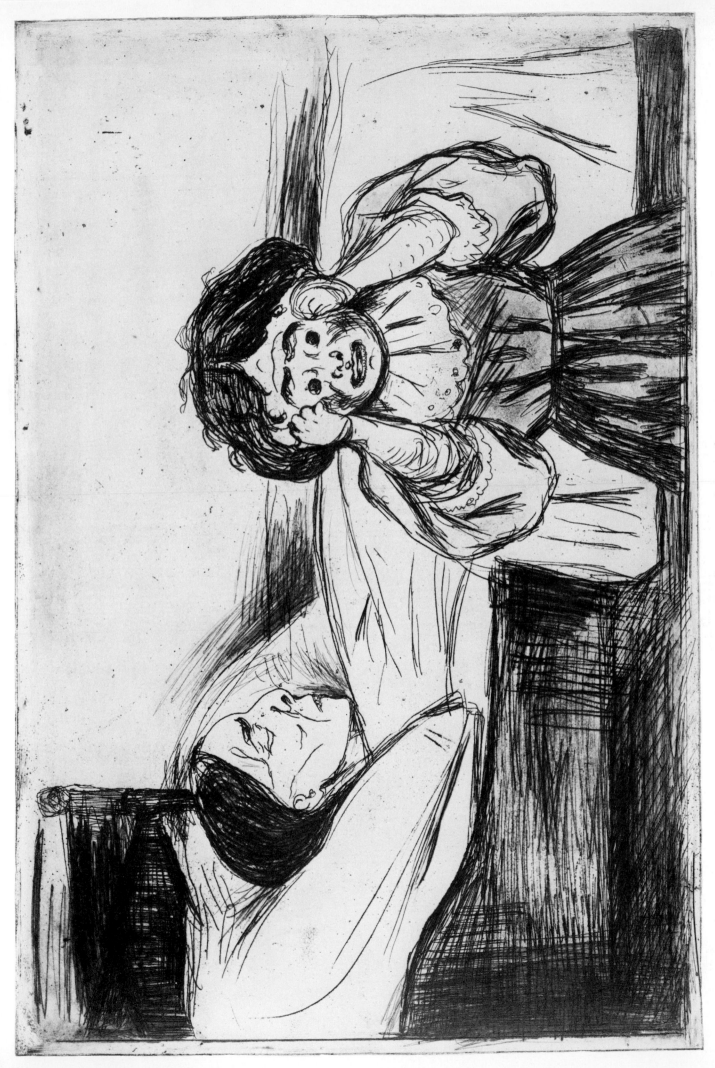

57 Dead Mother. 1901. Etching and aquatint.

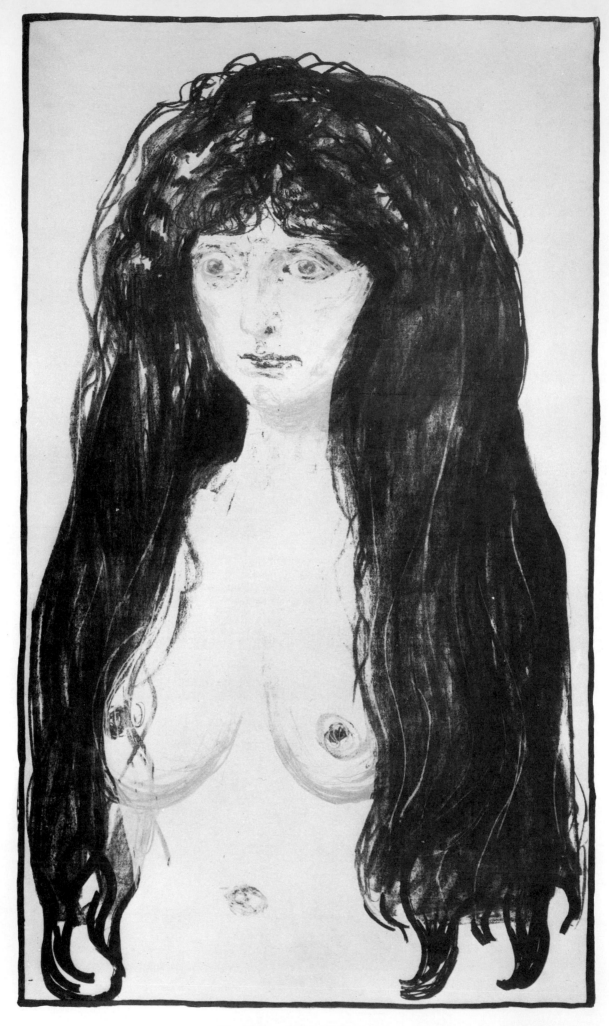

58 NUDE. 1901. Lithograph.

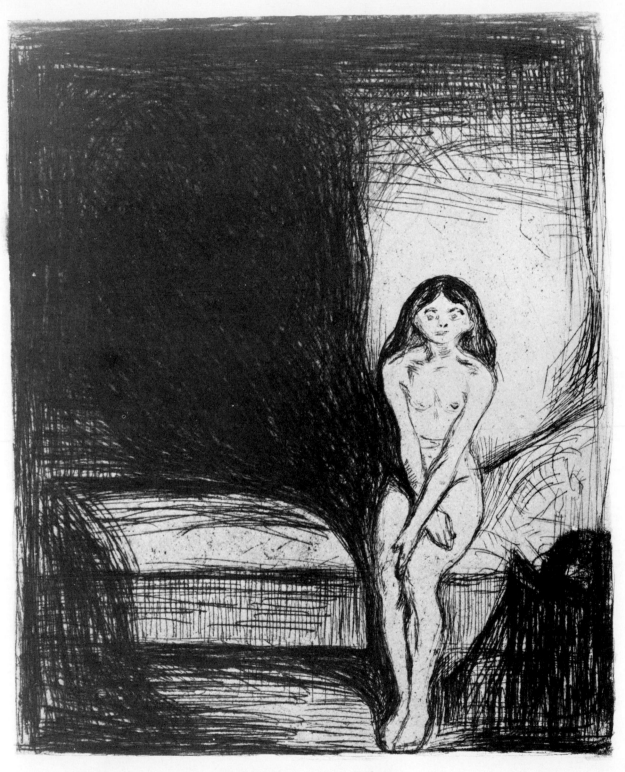

59 At Night. 1902. Etching.

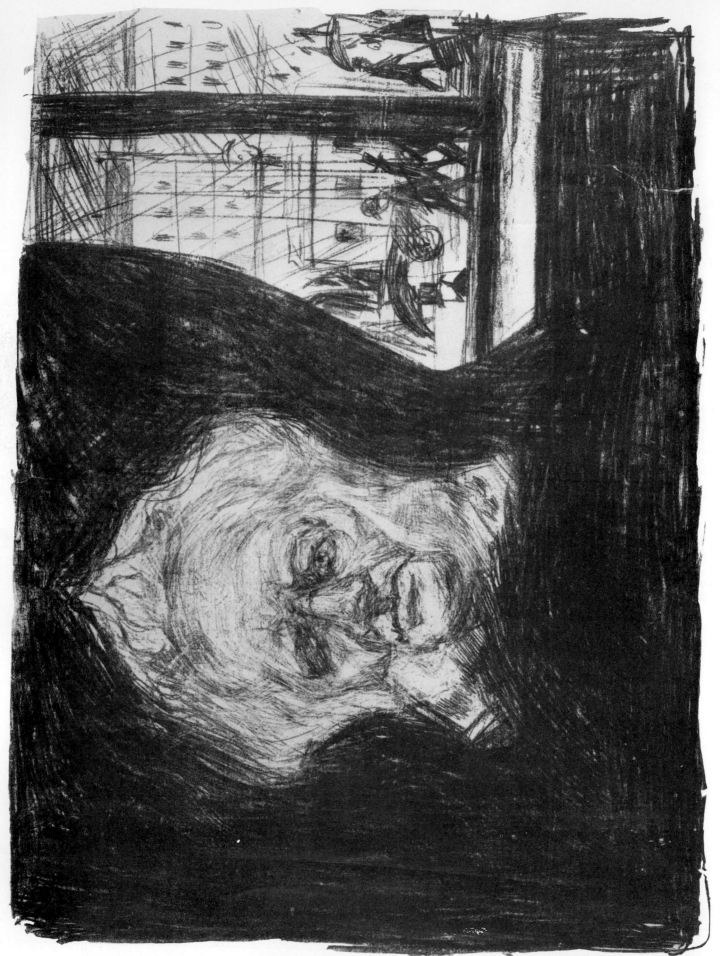

60 Ibsen in the Café of the Grand Hotel, Christiania. 1902. Lithograph.

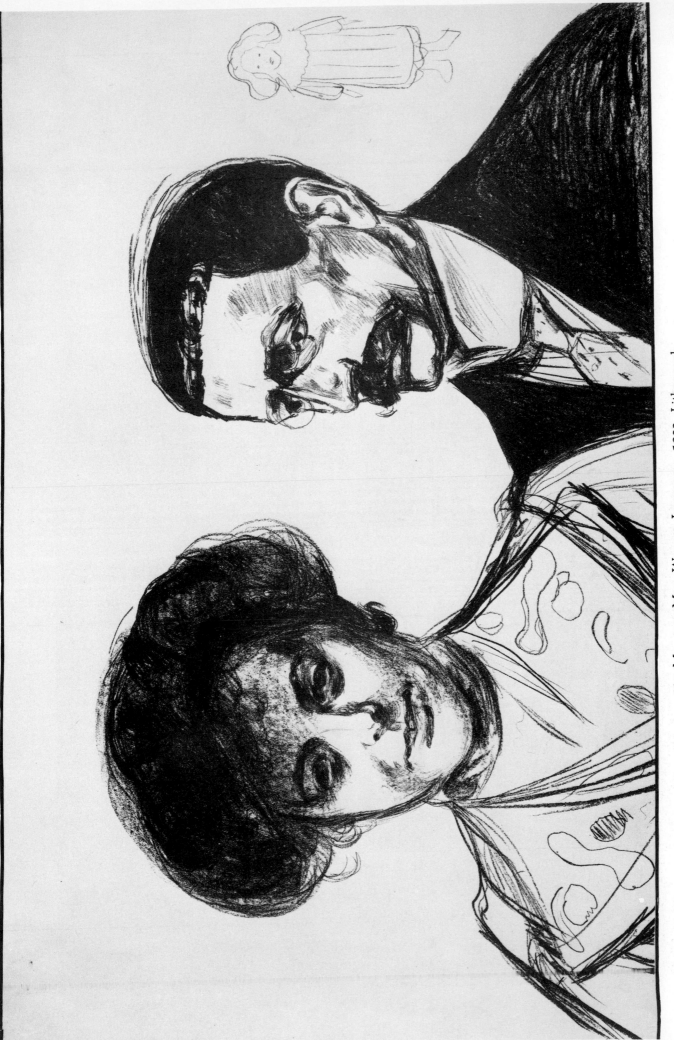

61 Mr. and Mrs. Walter Leistikow. 1902. Lithograph.

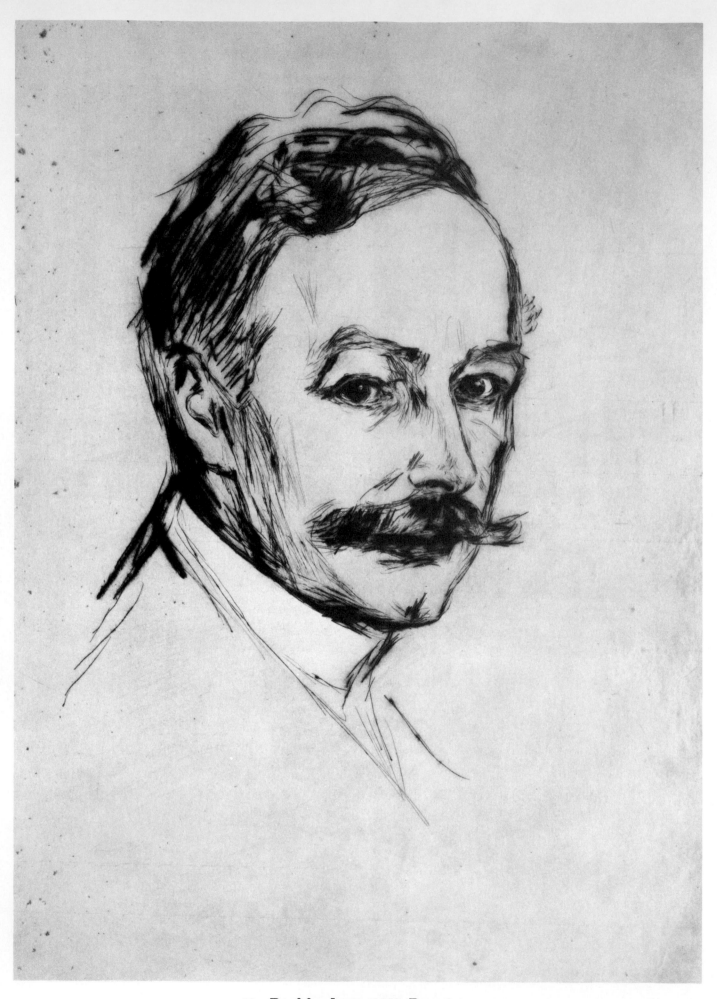

62 Dr. Max Linde. 1902. Drypoint.

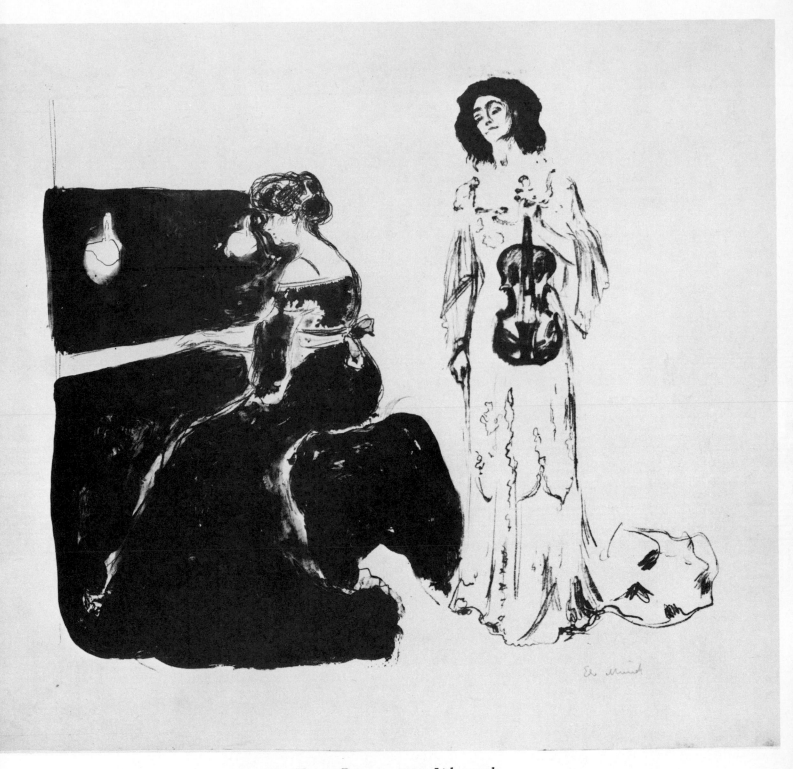

63 VIOLIN RECITAL. 1903. Lithograph.

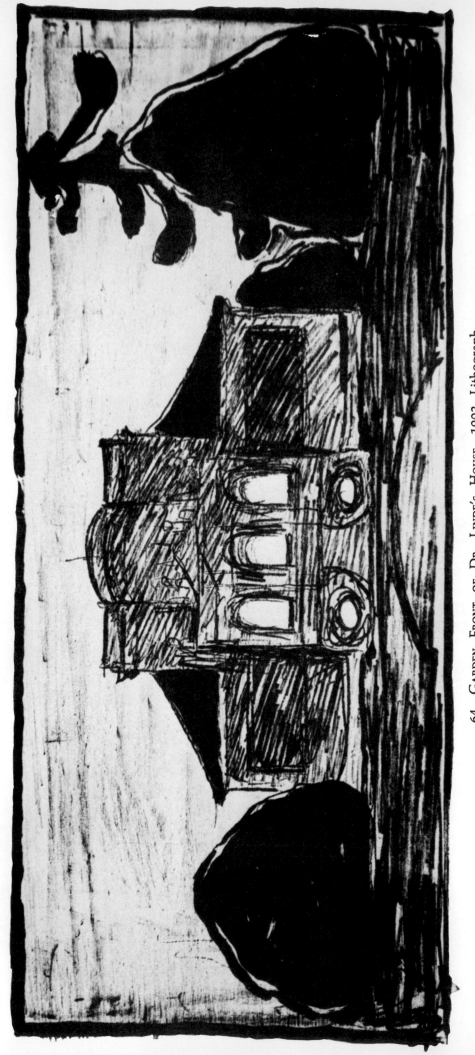

64 GARDEN FRONT OF DR. LINDE'S HOUSE. 1902. Lithograph.

65 LÜBECK. 1903. Etching.

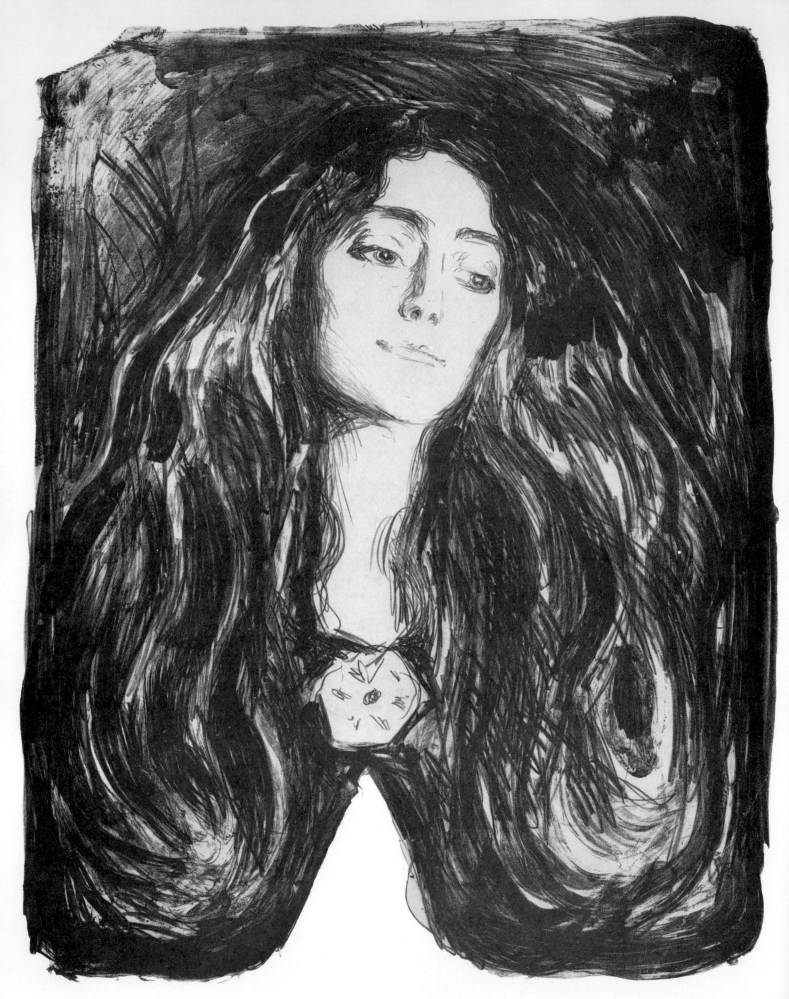

66 MADONNA. 1903. Lithograph.

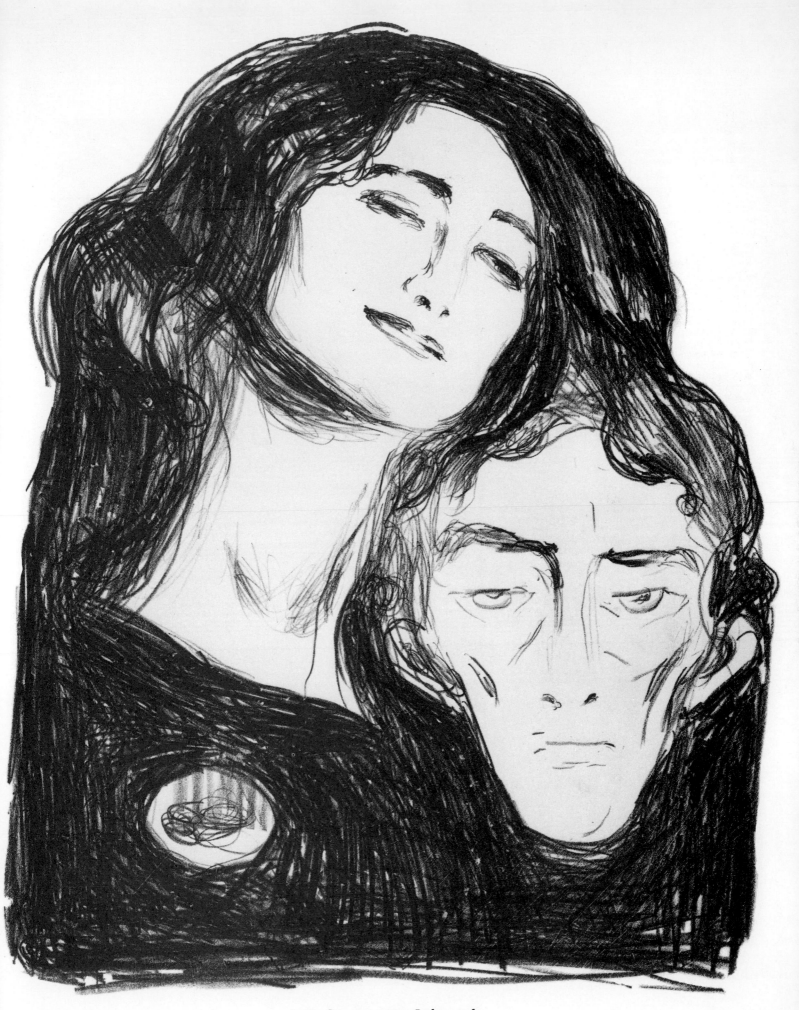

67 SALOME. 1903. Lithograph.

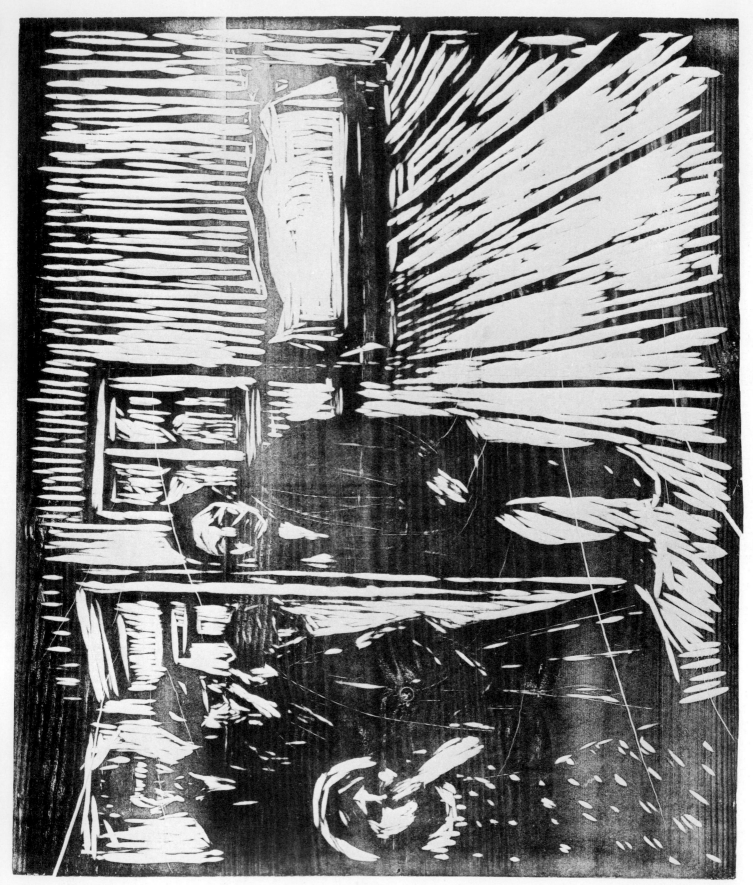

68　Visit of Condolence. 1904. Woodcut.

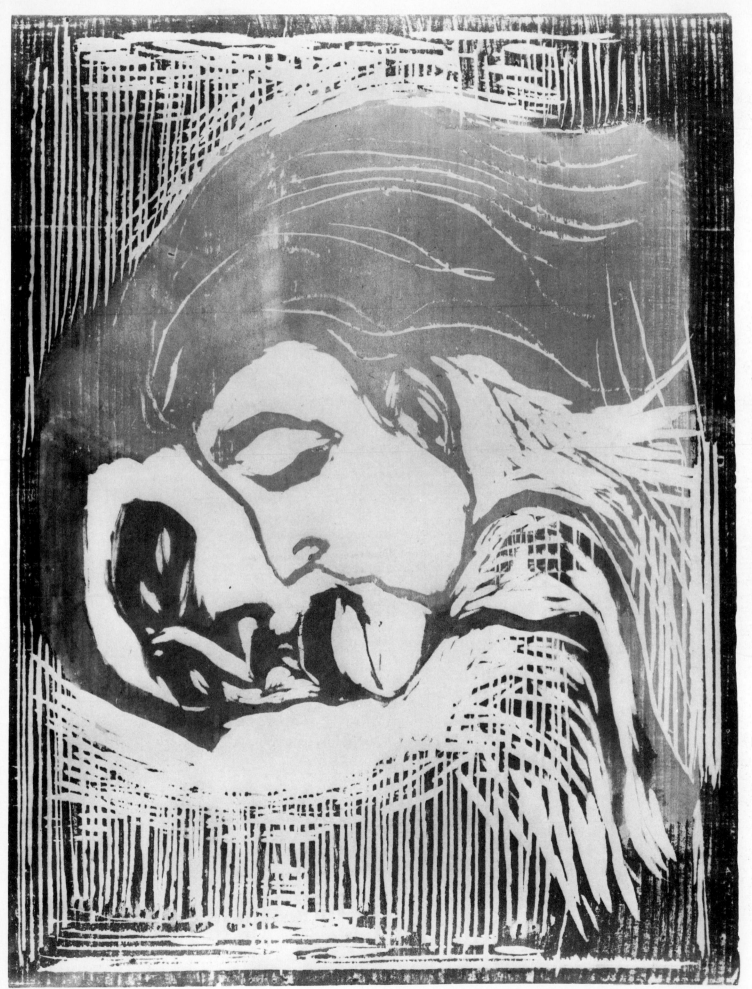

69 MAN AND WOMAN KISSING. 1905. Woodcut.

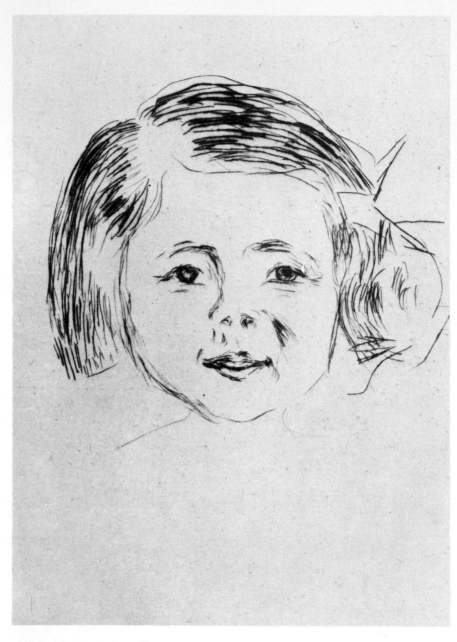

70 HEAD OF A CHILD. 1905. Drypoint.

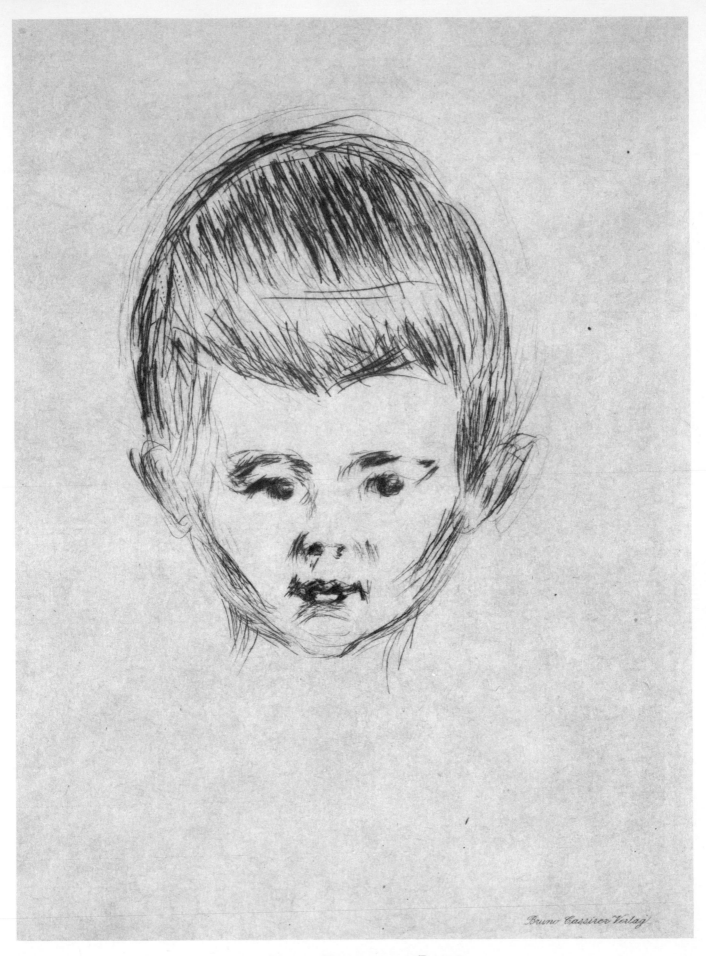

71 ANDREAS SCHWARZ. 1906. Drypoint.

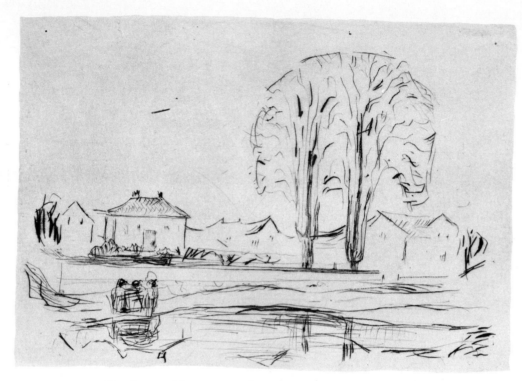

72 LITTLE NORWEGIAN LANDSCAPE. 1907. Drypoint.

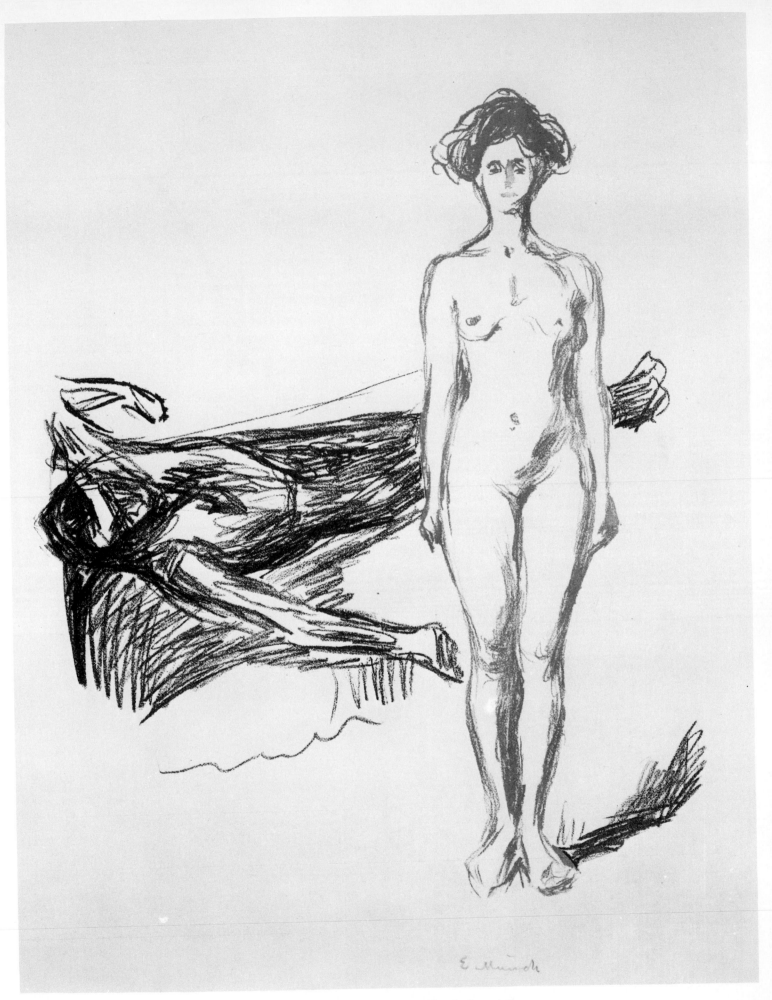

73 THE DEATH OF MARAT. 1906/7. Lithograph.

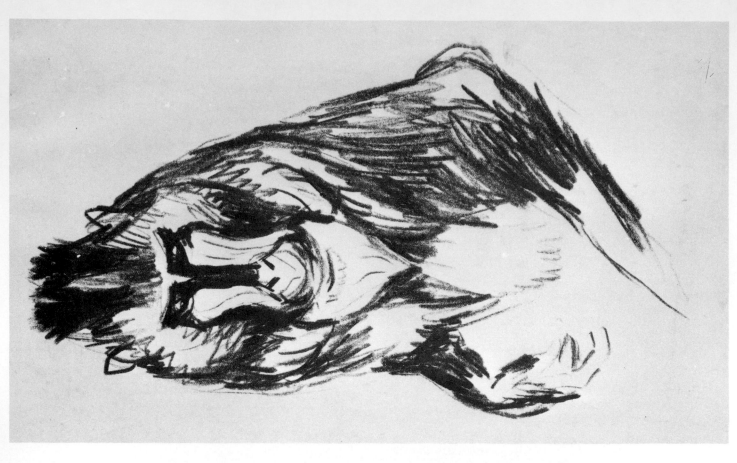

74 *Left:* TIGER'S HEAD. *Right:* MANDRILL. 1908/9. Lithographs.

75 THE FOREST. 1908/9. Lithograph.

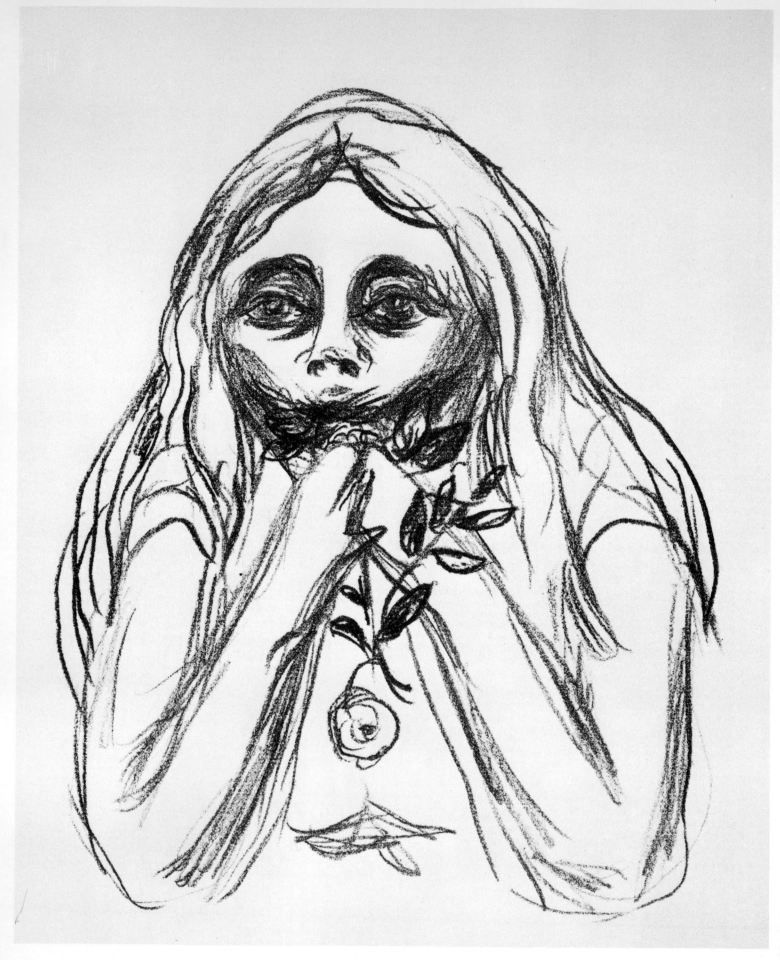

76 OMEGA'S EYES. 1908/9. Lithograph.

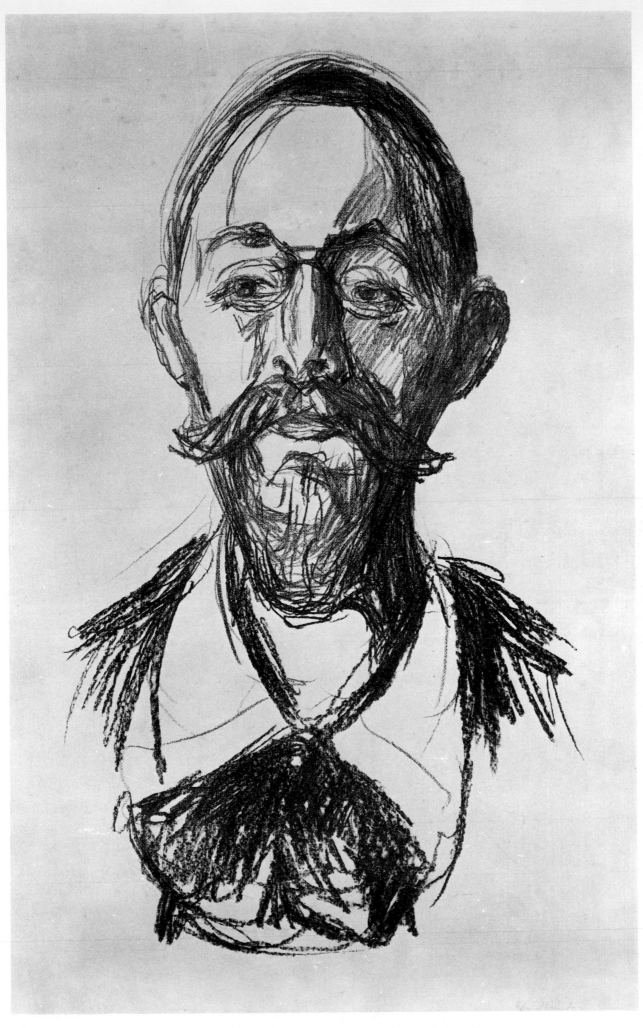

77 PROFESSOR DANIEL JACOBSEN. 1908/9. Lithograph.

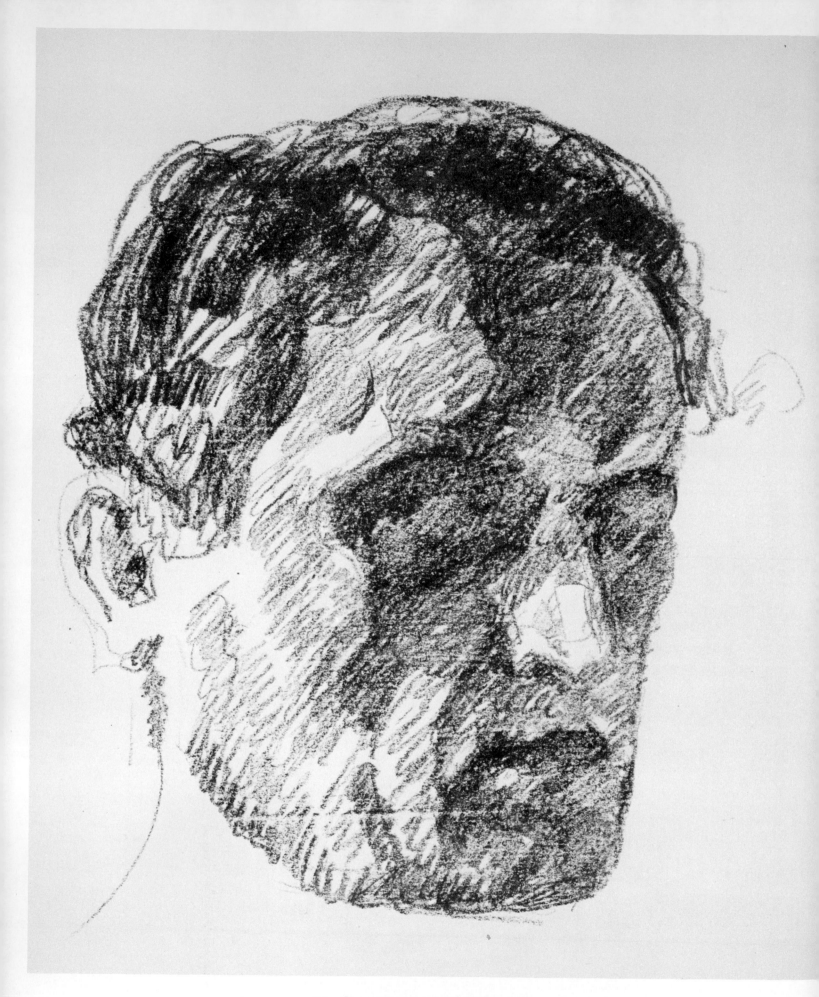

78 SELF-PORTRAIT. 1912. Lithograph.

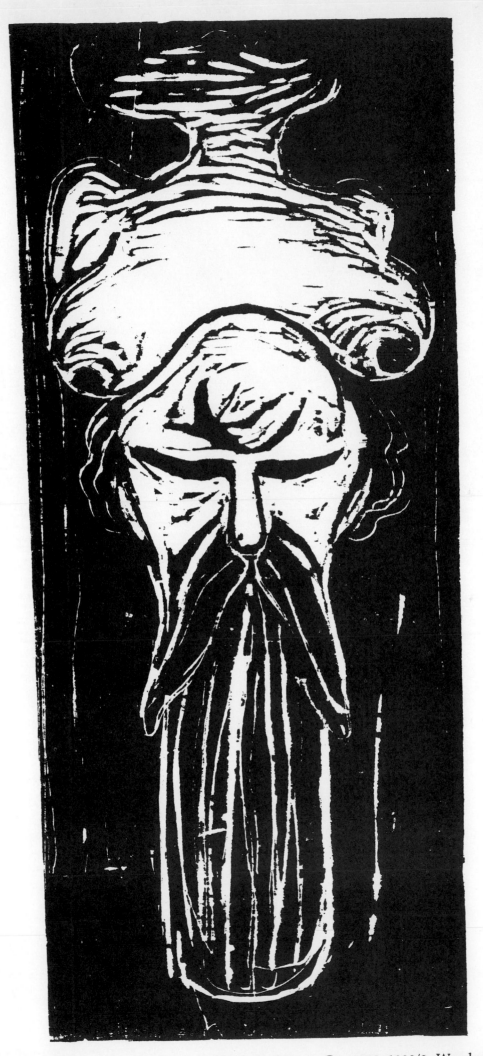

79 HEAD OF A MAN BELOW A WOMAN'S BREAST. Ca. 1898–1908/9. Woodcut.

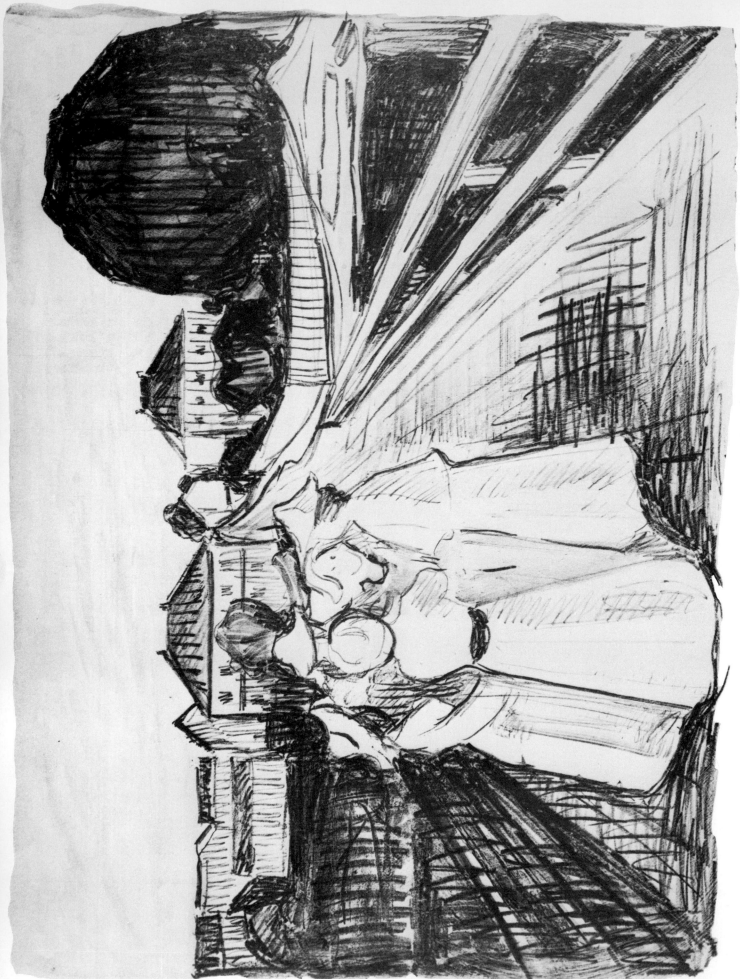

80 ON THE JETTY. 1912. Lithograph.

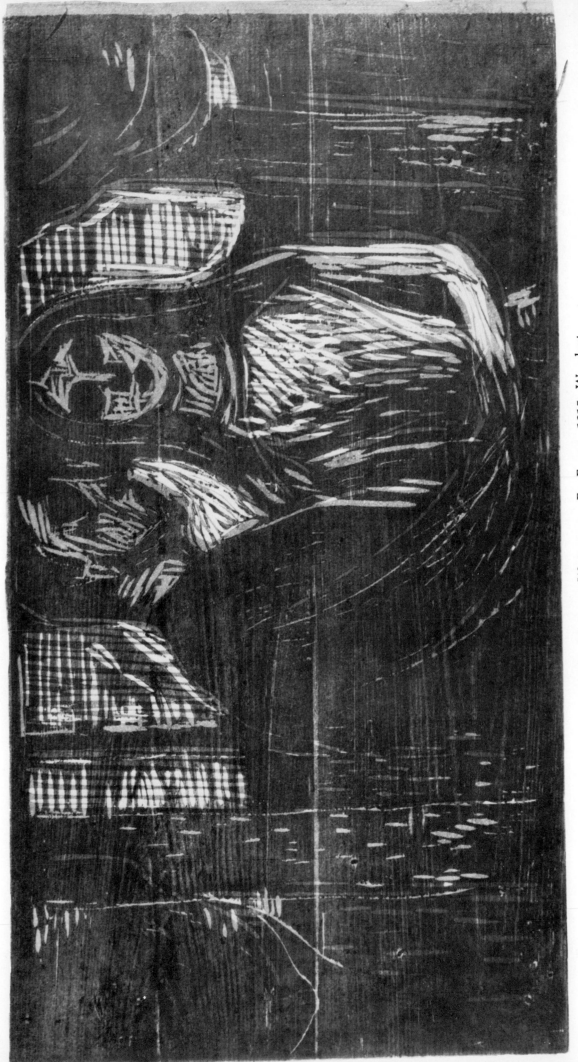

81 Young Man and Woman in a Fir Forest. 1915. Woodcut.

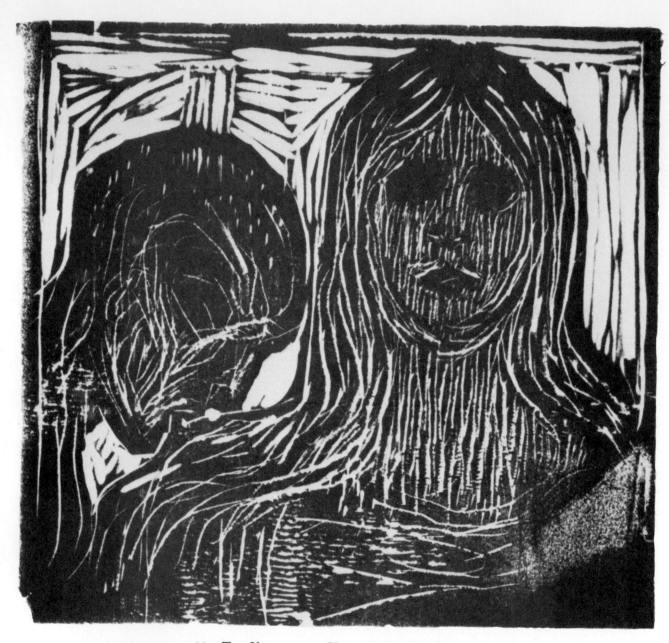

82 THE KISS ON THE HAIR. 1915. Woodcut.

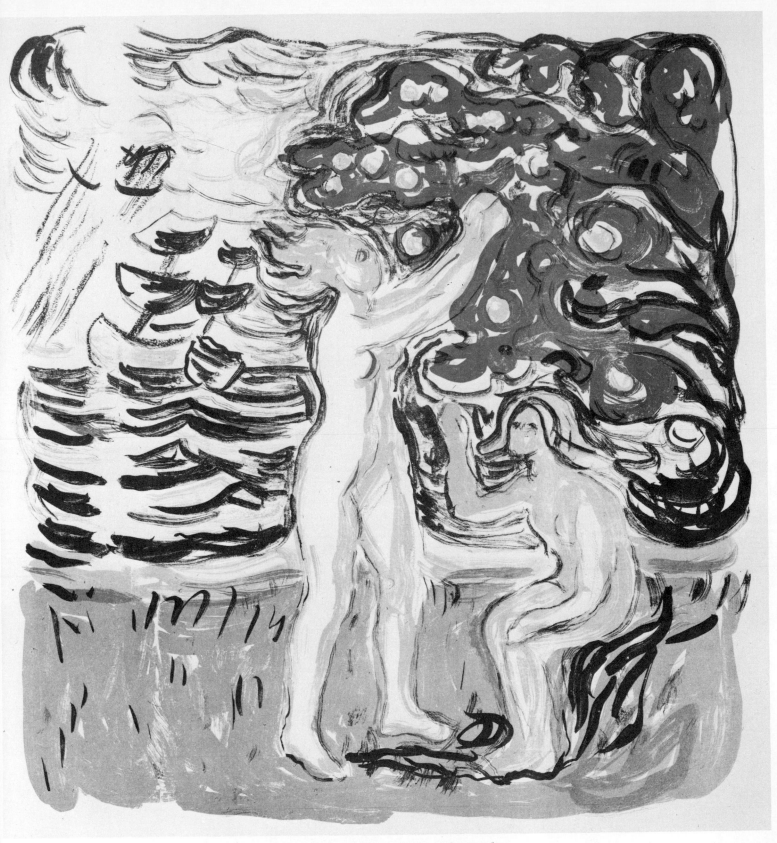

83 PICKING APPLES. 1916. Lithograph.

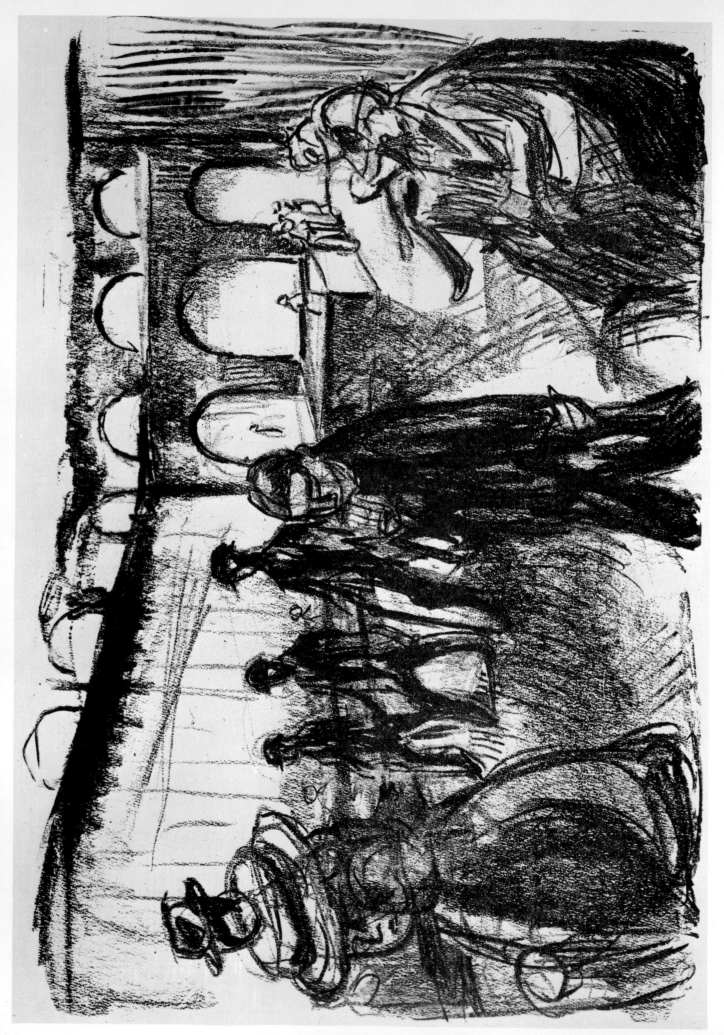

84　The Pumproom at the Wiesbaden Spa. 1920. Lithograph.

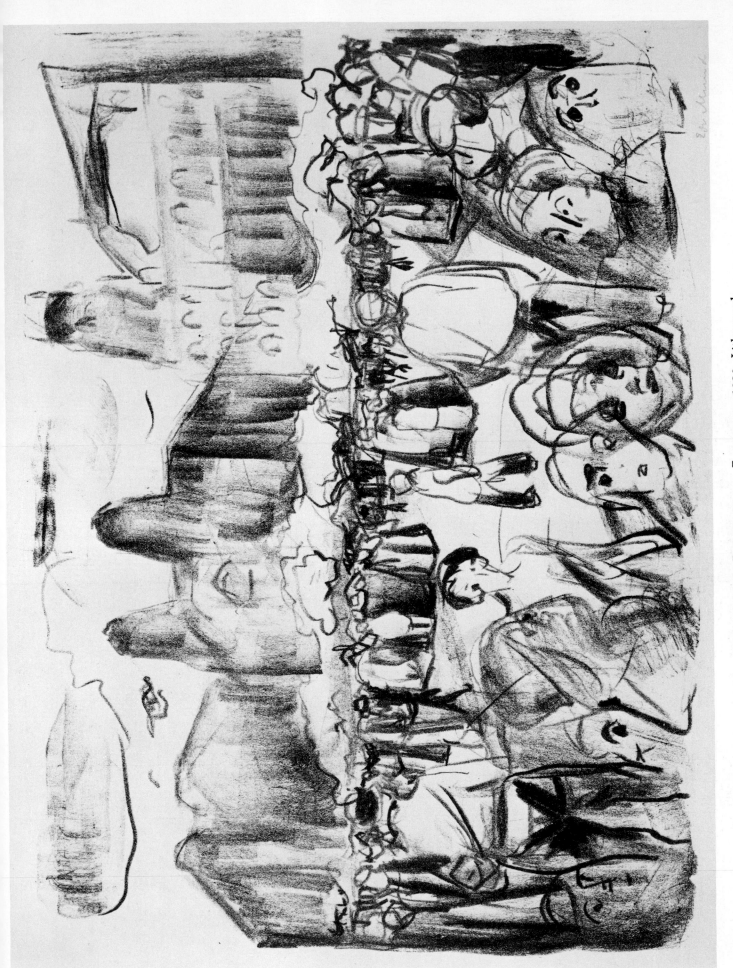

85 Crowds in the Bahnhofplatz, Frankfurt. 1920. Lithograph.

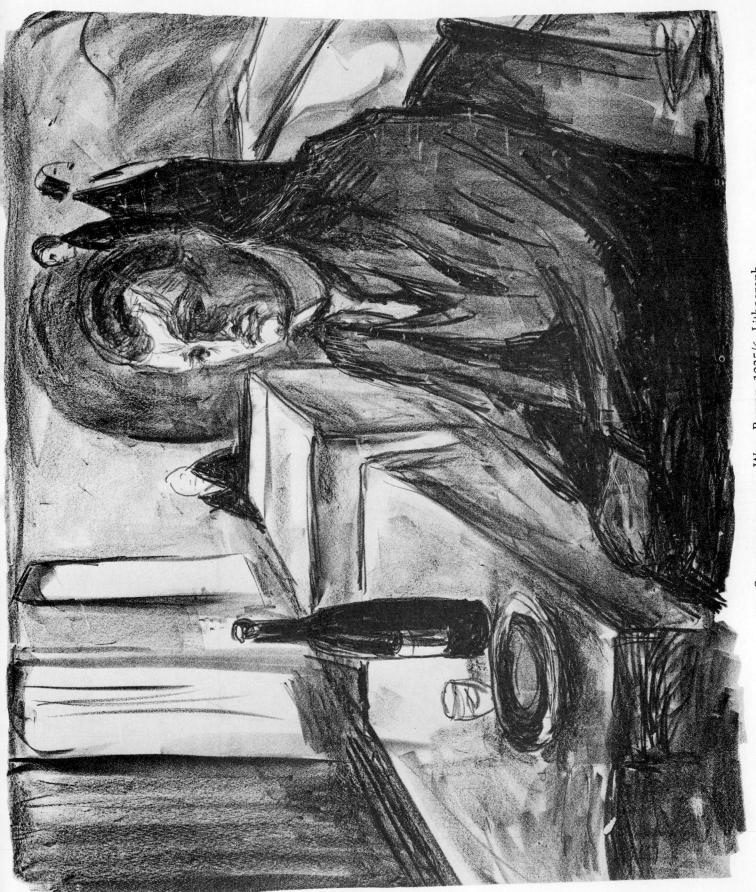

87 SELF-PORTRAIT WITH WINE BOTTLE. 1925/6. Lithograph.

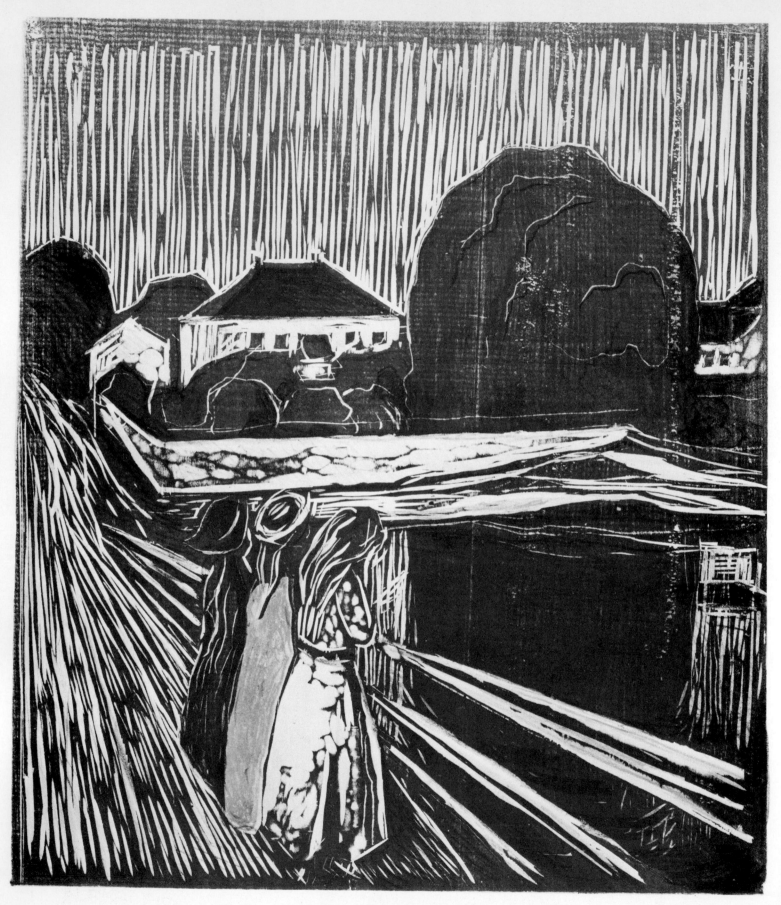

88 GIRLS ON A JETTY. 1920. Woodcut and lithograph.

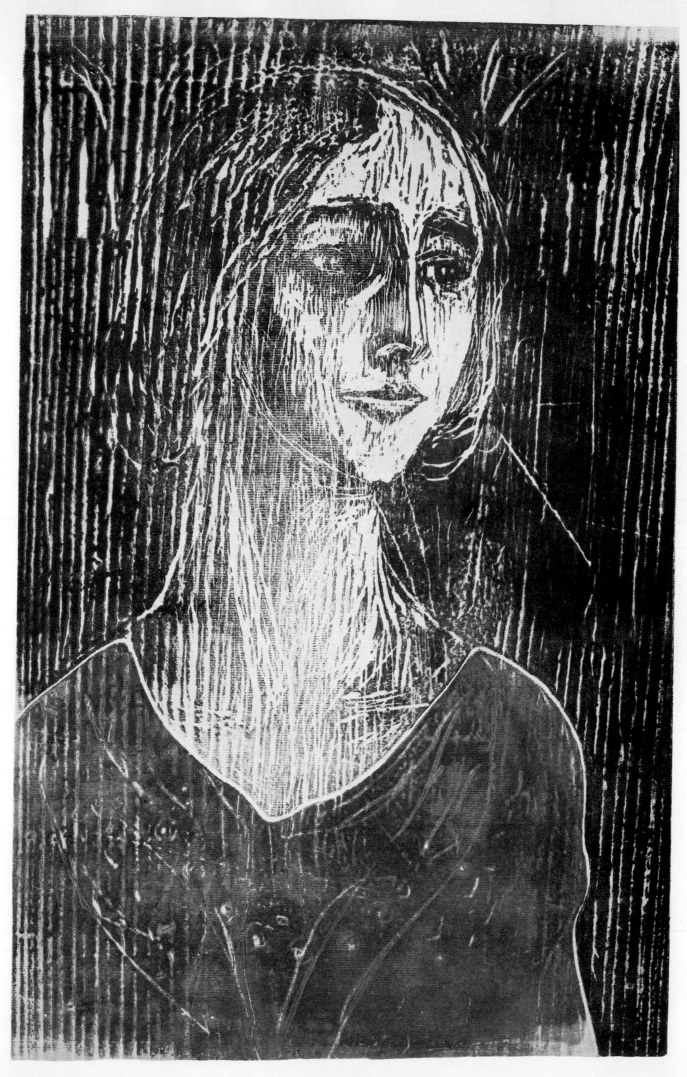

89 BIRGITTE, III. 1931. Woodcut.

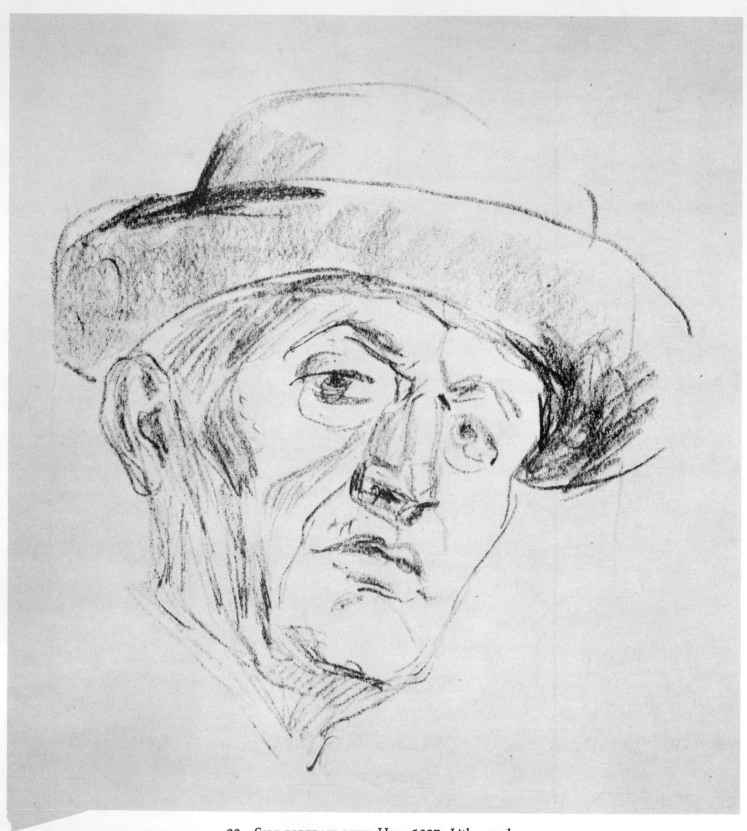

90 SELF-PORTRAIT WITH HAT. 1927. Lithograph.